For most of it
I have no words

DEWI LEWIS
PUBLISHING

"History is amoral: events occurred. But memory is moral; what we consciously remember is what our conscience remembers. History is the Totenbuch, The Book of the Dead, kept by the administrators of the camps. Memory is the Memorbücher, the names of those to be mourned, read aloud in the synagogue. History and memory share events; that is they share time and space. Every moment is two moments."
– Anne Michaels

Taken from the book 'Fugitive Pieces' by Anne Michaels published by Bloomsbury Publishing Plc in 1997

For most of it
I have no words

Genocide · Landscape · Memory
Photographs by Simon Norfolk
Essay by Michael Ignatieff

First published in the United Kingdom in 1998 by
Dewi Lewis Publishing
8 Broomfield Road
Heaton Moor
Stockport SK4 4ND
England
+44 (0)161 442 9450

ISBN: 1-899235-66-3

Design by Martin Colyer
Duotone separations by EBS
Printed in Italy by EBS, Verona

Contents

Essay by Michael Ignatieff

Your Genocide, My Self-Defence

Genocide is a new word for an old crime. Compounded of the Greek word for tribe and the Latin suffix for murder, it was coined in 1943 by a Polish jurist, Raphael Lemkin, to describe any systematic attempt to exterminate a people or its culture and way of life. It is a 'crime against humanity', one of a select body of offences which even though directed at particular tribes are crimes against all.

Genocide is a violation of certain universal intuitions about when it is appropriate for human beings to die: when they are ready, when their time is up, when they take up arms, when they are guilty, and so on. That they should die simply because of the colour of their skin or the contours of their face violates a basic presumption of human innocence. No one should be killed simply for being who they are. If there are moral universals in the world, one would have thought that this would be one.

It is not. To understand this point simply imagine what would happen if an exhibition of the photographs on the following pages were mounted in the main lobby of

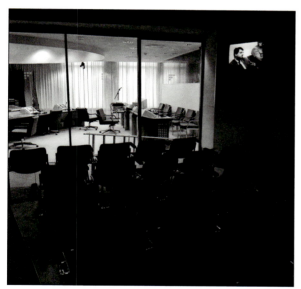

The UN International Criminal Tribunal for the Former Yugoslavia, The Hague. Seating area for observers

the United Nations building in New York. The Turkish delegation would protest against the inclusion of the Armenian photographs; the Americans would be outraged at the inclusion of Vietnam; the British would object bitterly to the inclusion of Dresden; and Russians might well be indignant at the inclusion of the Ukrainian famine. Perhaps only the Germans would keep quiet. The genocide committed in their name remains the only one beyond argument.

The truths we hold to be self-evident are the truths that divide us. This year marks the fiftieth anniversary of the Genocide Convention, passed by the United Nations in December 1948 and ratified by the parliaments of all but a handful of member states, the United States finally ratifying only in 1986. Ratification turned out to mean little: the convention remained a nullity for 50 years. Finally, in 1998, a handful of the perpetrators of the Rwandan killings were convicted under the terms of the Convention and a Bosnian Serb stood trial on the charge at The Hague. Finally, too, the world got around to creating the permanent international tribunal it had talked about setting up ever since 1948. Yet even here, at the Rome conference to set up the tribunal, where one might have expected moral unanimity, there was deep

division with the United States delegation seeking to restrict the jurisdiction of the tribunal. Until such a court is established, with permanent jurisdiction over crimes of genocide and related war crimes, genocide can never acquire the clear meaning which only successful prosecutions and an accumulating case law ever give to a crime. Until then, until genocide acquires a jurisprudence, the word will remain in a dubious moral libo. Perpetrators excuse themselves of the charge of genocide by claiming that they were merely defending themselves against the genocidal intentions of their enemies, thus getting their retaliation in first. Victimized peoples inflate the injustices they have suffered into genocide in order to seek absolution and sympathy. To claim to have been the victim of a genocide can be an essential moral step in claiming reparations, self-determination and statehood. In the process, the coinage has been debased. What remains is not a moral universal which binds us all together, but a loose slogan which drives us apart.

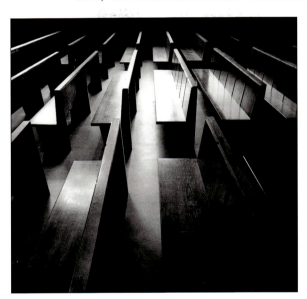

The courtroom of the Nürnberg War Crimes trials. Seating for observers

By including Dresden in his collection of photographs, Simon Norfolk is raising the question of these suspect moral equivalences. Genocide is a crime whose identity turns on intention. What intention was at work in RAF Bomber Command in February 1945? To harm and punish German civilians, certainly. To exterminate them as a people? Certainly not. Moreover, victims whose state is engaged in war belong in a different category to victims who have not taken up arms. The people of Dresden were citizens of a state waging an exterminatory war and the bombing was an act of war. Once the conflict was over, the bombing ceased. It was as just a war as ever was fought, but its justice does not justify war crimes. And a war crime Dresden most certainly was: indiscriminate slaughter of a civilian population for no military or tactical objective, or none that can be subsequently defended. That no one was punished for Dresden is an inequity of victor's justice. But injustice is not undone by misdescribing the crime.

Likewise, the indiscriminate bombing of civilians and the defoliation of jungles in Vietnam were war crimes. Anyone who doubts this should inspect the consequences, unsparingly catalogued in the photographs of deformed children and their fiercely accusing stares. But genocide is not a simple synonym for horror. It is a category of horror, distinct unto itself. Instead of defining a discriminate category of evil,

the word genocide has become an invitation to abandon all discrimination. It might seem better to abandon the word altogether, were it not that the crime it describes continues to exist.

Genocide as utopia The impulse to commit genocide is ancient. The list of tribes which have been exterminated may be as long as the list of animal and plant species which we have rendered extinct. This exterminatory impulse is much misunderstood. It is actually a kind of longing for utopia, a blood sacrifice in the worship of an idea of paradise. What could be more like paradise on earth than to live in a community without enemies? To create a world with no more need for borders, for watch-posts, a world freed from fear in the night and war by day? A world safe from the deadly contaminations and temptations of the other tribe? What could be more beautiful than to live in a community with people who resemble each other in every particular? We all long for harmony, for an end to the seemingly interminable discord of human relations. What could be more seductive than to kill in order to put an end to all killing? This utopia is so alluring that it is a wonder the human race has been able to survive it at all. Certainly genocide enlists lower motives than the longing for utopia. The men with the machetes may have no

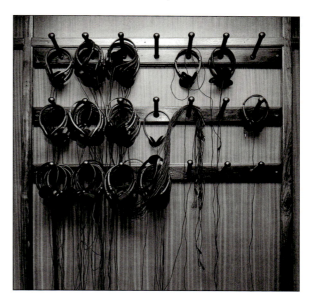

The UN International Criminal Tribunal for Rwanda, Arusha. Translation headphones for observers

utopia in mind higher than at last possessing their neighbour's farm or property. But low motives aren't enough. Genocide is such a radical cleansing, such a violation of the normal order of things, that it must seek permission for itself. It must enlist the highest of motives, the biggest of dreams. Most genocides begin with orders from above, with hate-filled campaigns on the radio, with rabid invocations of the people's need to cleanse themselves of pollution. Beyond the hate, however, the authorities always promise a calm after the cleansing storm and a world freed of enemies and fear. This utopia both glorifies venal motive and silences residual scruple.

At the end of this century, we can see that such impulses have not ended with the defeat of fascism and the collapse of communism. They remain permanent human temptations. In places such as Bosnia and Rwanda, the technology of extermination has been more or less traditional: the machete and the gun. But now utopia can enlist

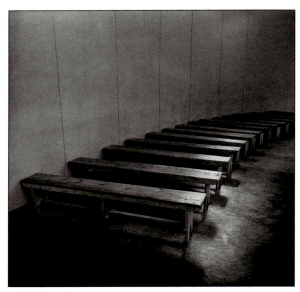

Nyamirambo courthouse, Kigali, Rwanda.
Seatingfor observers

powerful new technologies. We could now destroy the human species itself and the very planet which is our common home. There is an awesome grandeur about these facts - it would be foolish to suppose they awaken only misanthropy and self-disgust. For even those who are frightened by belonging to such a species feel a kind of awe at possessing such sublime, total destructiveness. It is sentimental to think that we worship only what is life-giving, creative and hopeful about ourselves. We also worship - and aspire to - our God-like powers of extermination. The rituals of our ancient religions seem humble and modest things beside this fierce idolatry.

Because genocide offers a kind of utopia, it is a temptation we have always had to struggle to overcome. It is so appealing that for millennia the violence used to achieve it was not perceived as a crime. What could be more sensible than to rid the forest of the tribe whose existence menaces your own? Until very recent times, it was not self-evident that other tribes belonged to the same species. While human life may have existed on the planet for a million years, it is possible that only in the last thousand have men believed that we belong to a single tribe. The crime of genocide cannot exist as a moral category until this consciousness is established. This was the work of the monotheistic religions, who bound the tribes together by preaching that all men were subject to the same master. It was not until the European Enlightenment that this religious intuition was secularized, when it became a commonplace to think of human beings possessing a common nature and a common set of moral obligations. And only in our century, in the last fifty years, has it become possible to declare a set of universal human rights. So the history of genocide teaches us something about the history of the century in general: ours has been the first to perfect mass murder and the first to understand the exact sense in which this is a crime. Our future depends on whether our consciousness of it as a crime is equal to the strength of it as a temptation.

The Scene of the Crime

In the classrooms of the mission school in Nyarubuye, Rwanda, the bodies of the children have decomposed. The ragged clothes which shroud their skeletons are falling apart. The bones are white, picked clean.

Near the ruins of the crematoria at Auschwitz, Mogen David stars in

wood once were placed to mark the spot where human ash drifted down upon the ground. But the ash has now returned to the earth and the wooden stars themselves are turning to dust.

The malignity in these places is dissolving. Bones crumble; human ash returns to soil; teeth, sandals, hair, bullets, axes disperse into atoms and molecules. The evidence of evil, like the evidence of good, obeys the universal laws of entropy. Heat cools, matter disintegrates, memories fade.

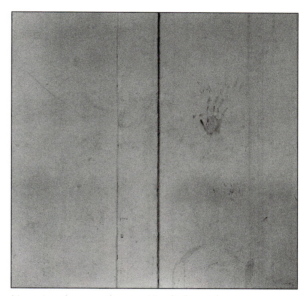

Nyamirambo courthouse, Kigali, Rwanda. Handprint on a wall.

These photographs document the downward drift of forgetting: how flowers push up through graves, how birds fill the sky over Dresden, a sky that once was thick with bombers; how snow is covering over the graves of the Ukraine, and the fields of Anatolia where Armenians were marched to their deaths; and how the sands of the Namibian desert have covered the final traces of the Herero people.

Were we ignorant of what happened in such places, the sunlit snow of eastern Anatolia and the patterned sand of the Namibian desert might seem sublime. But since we know what nature has witnessed, nature loses its innocence. The desolation in these photographs is beautiful, but their beauty is suspect. They play on the basic amorality of the aesthetic. But they are not guilty - so it seems to me - of the charge that they beautify what is obscene. They are documenting vanished crimes and in doing so they put their own beauty into question. A sand dune no longer looks innocent when we know that it covers the traces of a death march.

What these photographs tell us is that even infamy is subject to entropic decay. Even large and terrible crimes are eventually forgotten; even horror turns into dust and sand. This is hard to bear. We do not want to live in a world where crime escapes punishment, where evil escapes being called by its proper name, where infamy is swallowed up by sand and wind. Entropy is a moral scandal. For if everything is forgotten, if all headstones decay, what is the point of grieving?

Evil counts on the certainty that grass will cover the limepits, that the ground will swallow up the bullet-casings, that human voices will eventually fall silent and memory fail. A German history of the destruction of the Herero in 1904 speaks of the 'sublime silence of infinity' stifling the cries of the dying. Demonic cynicism often lays claim to the sublime. For if everything ends in the silence of infinity, why should evil matter?

Entropy makes remembering an obligation. In remembering we make our stand against the indifference of nature. But these pictures make clear what memory is up against and why remembering takes faith. Nature will not help. The best markers are those entered in the human mind and transmitted from generation to generation, though even these are no match for nature. Photographs decay; books disintegrate; stories falsify and beautify and finally betray those they wish to save. For as these pictures show, nothing, not even infamous crime, is immortal.

In the Russian Orthodox memorial service for the dead, the believers sing the Viechnaya Pamyat: 'Eternal Memory, Eternal Memory grant him O Lord.' The memory in question here is God's. It is perfect: every hair on our head is counted, and every one of our sins too. If we are forgotten by men, we will still be remembered by God. This is the consolation of the faithful. But where is the consolation of the faithless? The only consolation seems to lie in being reconciled to erasure by the winds.

It is not easy to be at peace with what these pictures tell us: that everything slowly vanishes, including our best efforts to remember. All human culture is an attempt to inscribe significance on life and to make human meaning and human connections endure. In our century, the crimes we have committed against each other have been so large, so persistent, so insane that they make us wonder whether this struggle has any point. For we have become a force of entropy ourselves; we have unleashed our own nihilism, our own drive to nothingness.

Genocide is the perfection of this drive towards oblivion. The dead were hurled into mass graves; corpses were piled on top of each other in a defilement which eliminated all singularity, dignity and meaning from dying. The difficulty of mastering genocide lies in the impossibility of restoring to each victim the singular attention which is due all humans in the hour of their deaths. We cannot now rescue each one of the victims from the anonymity of mass graves. Only God's memory could and then only if we could believe.

Belief is difficult because we have good reason to lack belief in ourselves. We were the ones who mechanized death, who created instruments - crematoria, shooting pits, death marches - which violated our own injunction that each human death should be given significance. And so a great work of reparation has been going on throughout the century, an unending, futile, yet essential attempt to undo the harm we have done to ourselves. We erect museums; statues; exhibitions; we collect the pictures of those who have died to restore an identity to their facelessness. These photographs express this universal need to redeem the dead through memory. Each photograph here is like those pebbles placed on the top of gravestones in Jewish cemeteries, the symbol of a link which not even death can destroy. But these photographs also tell us that nature will wash away both pebbles and headstones alike. All we can do is to place them there, over and over, from generation to generation, for as long as we can. ▪

Rwanda
The atrocity exhibition

On the night of 6th April 1994, Rwanda dissolved into a nightmare of bloodshed and destruction. On average 7,000 people were killed for each of the 100 days that the genocide lasted. The genocide of minority Tutsis and the murder of moderate Hutu opponents of the government was a political strategy adopted by a powerful clique at the centre of the nation to unite the majority behind an extremist platform. Every institution of the Rwandan state was dedicated to the mass slaughter of a part of its citizenry. The killings were meticulously planned in advance and put into effect by the armed forces, the gendarmerie, and the youth wings of the political parties, in particular the ruling party's armed thugs, the 'interahamwe'. As one writer has described it: one man was placed in charge of every ten households – every Tutsi was within reach of someone who knew them personally. "Pupils were killed by their teachers; shop owners by their customers; neighbour killed neighbour and husbands killed wives."

The testimony of survivors is heartbreaking. Mukarumanzi, a girl aged thirteen, was at the massacre at Nyamata church. Her testimony runs: "I tried to get up but it was in vain. I was very weak from my injuries and there were so many bodies everywhere that you could hardly move. A few children, perhaps because they were unaware of the dangers, stood up. I called to one of the children to help me. She was a girl of about nine. She replied that she could not because they had cut off her arms."[1]

Classroom

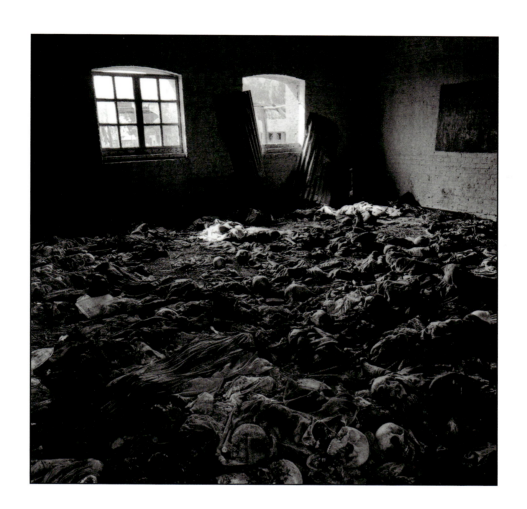

Virgin

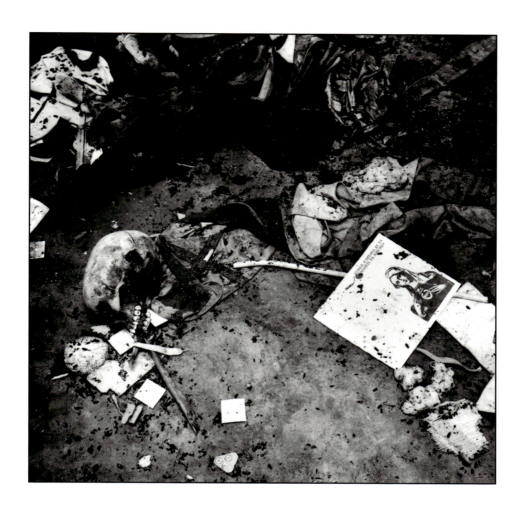

Massacre

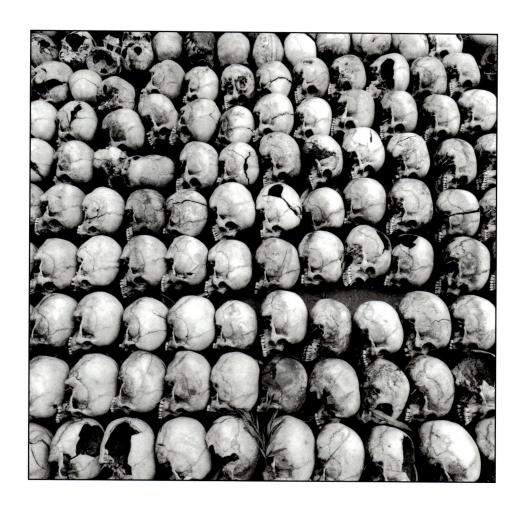

Altar

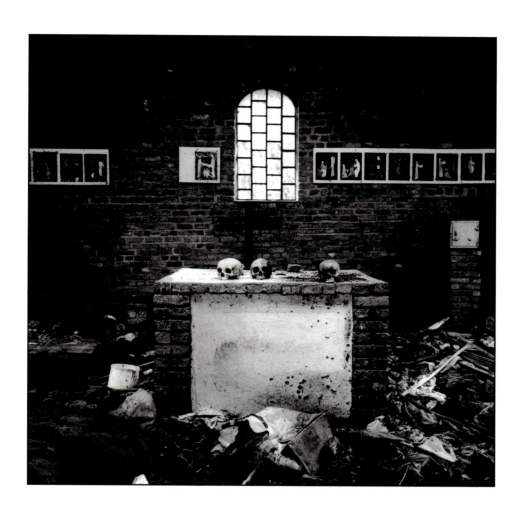

Halo

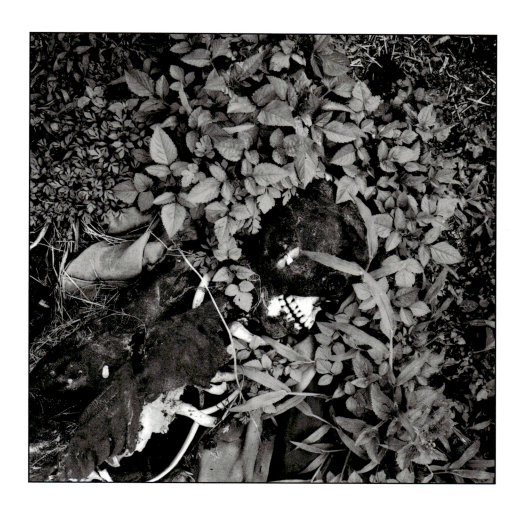

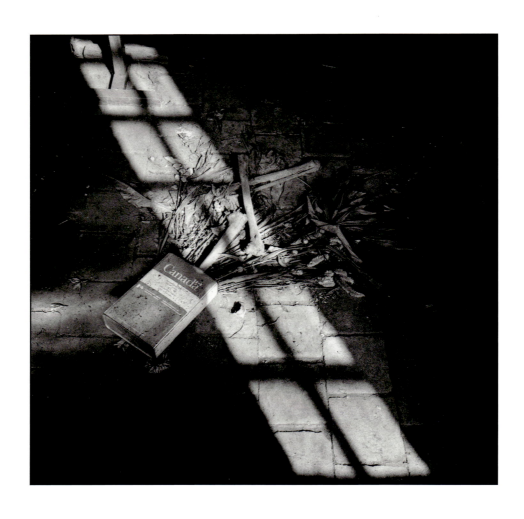

A boy's legs pushed into a vase

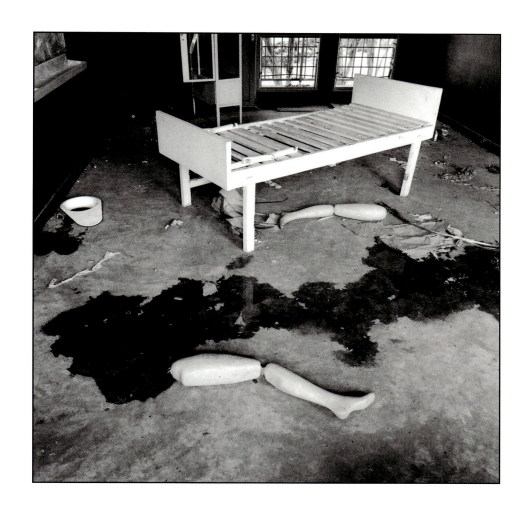

Infirmary

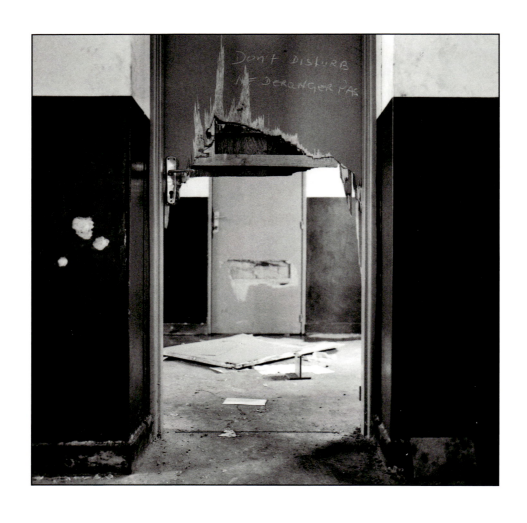

A teacher's office

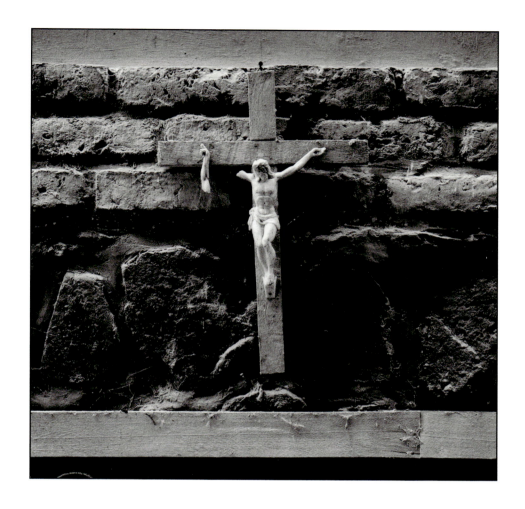

Classroom crucifix

Battleground

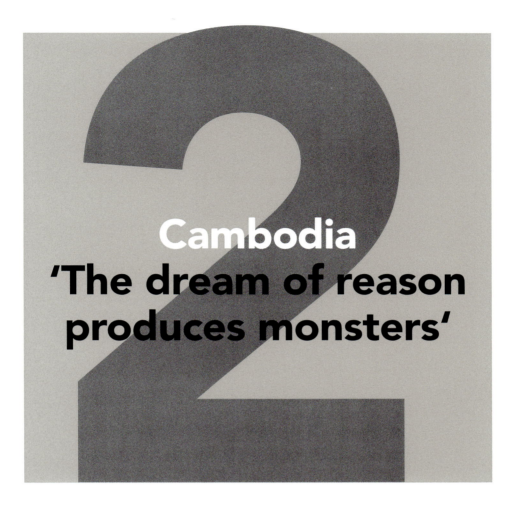

Cambodia
'The dream of reason produces monsters'

On April 17th 1975, the Khmer Rouge captured Phnom Penh and came to power in Cambodia. This day was declared 'Year Zero' of the new Democratic Kampuchea, and what followed amounted to the most brutal, autocratic and thoroughly revolutionary experiment the world has ever seen.

All vestiges of modern, urban living were eradicated in favour of medievalist peasant communism. Money, the market and private property were abolished along with education, religion and modern medicine. The cities were emptied and their inhabitants marched hundreds of miles into the countryside. All work was centrally allocated – 96% of the population became forced labour on vast collective farms. There was no freedom of movement or international contact. Everybody was to wear the same black peasant clothing. Families were abolished and children were encouraged to spy on their parents. All consumption was socialised, all meals were served from communal kitchens. The country became one vast concentration camp. Punishment for any infringement was always severe and usually fatal. Absurd, unattainable production targets were set, such as the instant tripling of the rice harvest. In less than four years, more than one million people – around one in seven of all the citizens of Kampuchea – died from malnutrition, maltreatment and overwork. At least 200,000 were executed for crimes against the state.

Democratic Kampuchea did, however, maintain some old traditions. For example, it still had a national anthem. Its lyrics were: 'Ruby blood that sprinkles the towns and plains/Of Kampuchea, our homeland/Splendid blood of workers and peasants.'[1]

Former college

Cambodia
'The dream of reason produces monsters'

On April 17th 1975, the Khmer Rouge captured Phnom Penh and came to power in Cambodia. This day was declared 'Year Zero' of the new Democratic Kampuchea, and what followed amounted to the most brutal, autocratic and thoroughly revolutionary experiment the world has ever seen.

All vestiges of modern, urban living were eradicated in favour of medievalist peasant communism. Money, the market and private property were abolished along with education, religion and modern medicine. The cities were emptied and their inhabitants marched hundreds of miles into the countryside. All work was centrally allocated – 96% of the population became forced labour on vast collective farms. There was no freedom of movement or international contact. Everybody was to wear the same black peasant clothing. Families were abolished and children were encouraged to spy on their parents. All consumption was socialised, all meals were served from communal kitchens. The country became one vast concentration camp. Punishment for any infringement was always severe and usually fatal. Absurd, unattainable production targets were set, such as the instant tripling of the rice harvest. In less than four years, more than one million people – around one in seven of all the citizens of Kampuchea – died from malnutrition, maltreatment and overwork. At least 200,000 were executed for crimes against the state.

Democratic Kampuchea did, however, maintain some old traditions. For example, it still had a national anthem. Its lyrics were: 'Ruby blood that sprinkles the towns and plains/Of Kampuchea, our homeland/Splendid blood of workers and peasants.'[1]

Former college

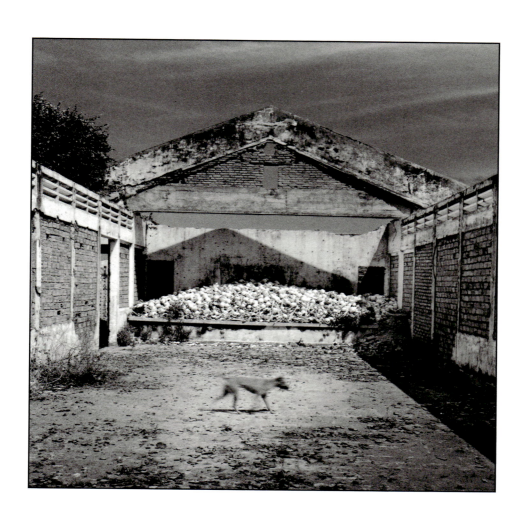

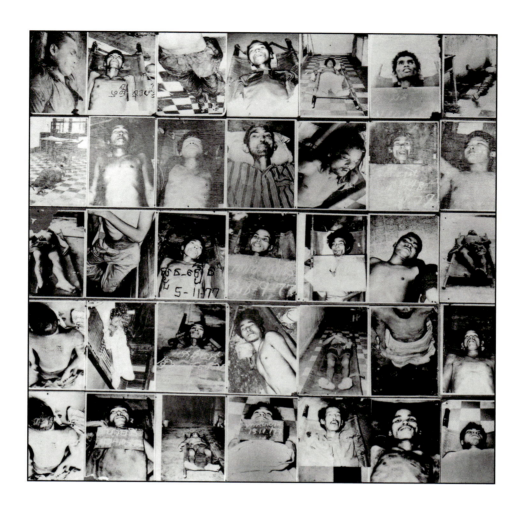

Ossuary

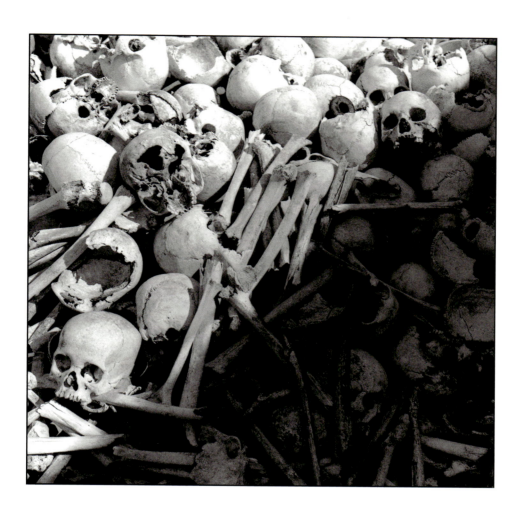

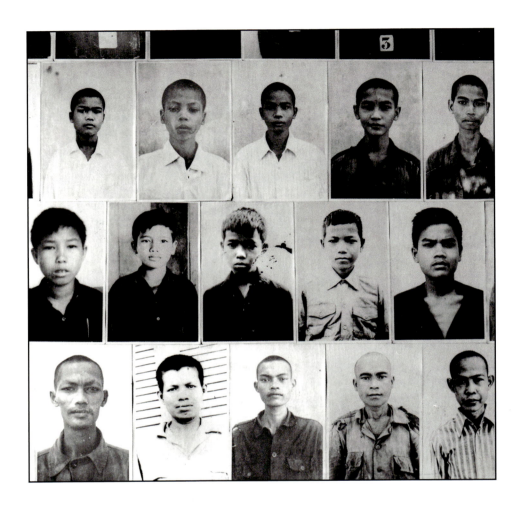

Condemned reactionaries

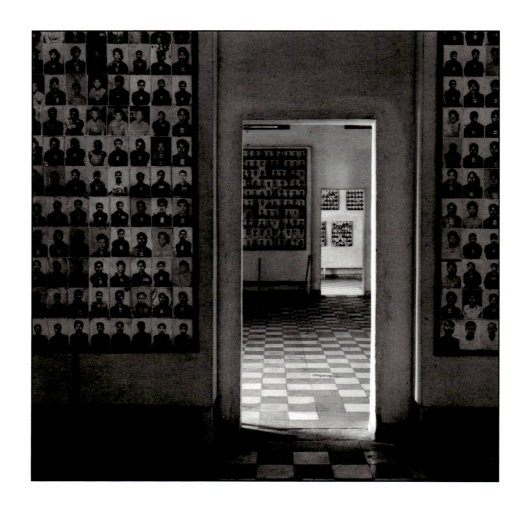

Inmates of a torture centre

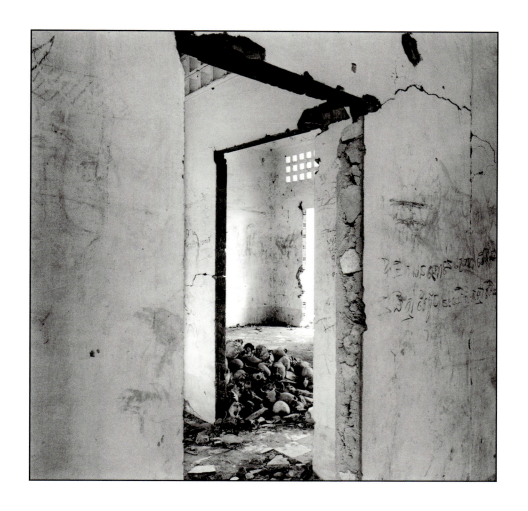

Former monastery

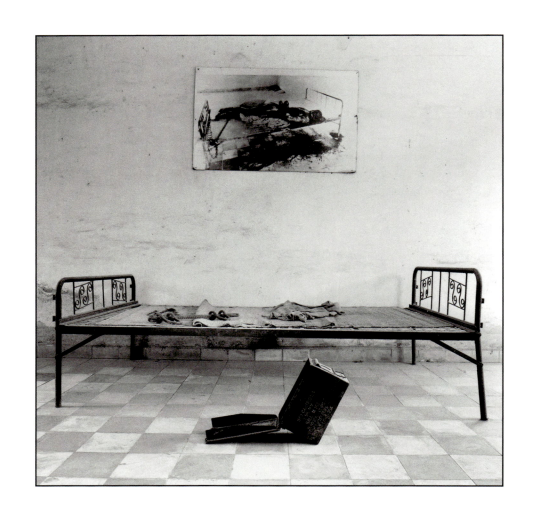

Bed

Former prison

Map of Cambodia

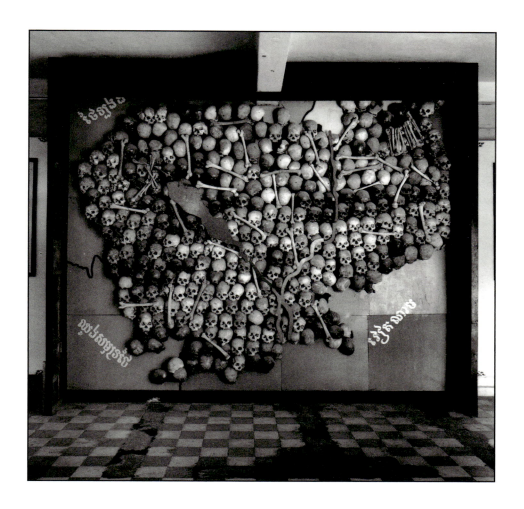

Vietnam
'They made a wasteland and they called it peace' – Tacitus

Whilst much has been said about the 58,000 American servicemen killed in Vietnam, little mention is made of the 4 million Vietnamese who lost their lives in that conflict. An army with computers and jets was unleashed upon a nation without shoes. Each day, 825 tons of bombs were unleashed upon this tiny country.

As is the case with the RAF over Dresden, much of the conduct of the war falls outside the definition of genocide – but both are in a grey area close to genocide. What happened in these cases was that the technical capacity and enthusiasm for waging war ran far ahead, and out of control, of the capacity for choosing targets. This unlimited capability for killing collided with a sweeping hatred of the entire enemy group and a murderous disregard for distinguishing the guilty from the innocent; combatant from non–combatant. Certainly, at the level of Generals these categories had clear blue water between them, but in the mangrove swamps of the Mekong Delta; the forests of the Central Highlands; or 5 miles above the B-52's bomb-box, they were one and the same – 'gook,' While the US did not commit pure genocide in Vietnam, they employed only one measure of their progress and rarely in history has there been an indicator of military success as crude and barbaric as the 'body count.'

The testimony of Salvadore LaMartina, one of the infantrymen who carried out the My Lai massacre was: Q: "Did you obey orders?"

A: "Yes, Sir."

Q: "What were your orders?"

A: "Kill anything that breathed."

Tank track

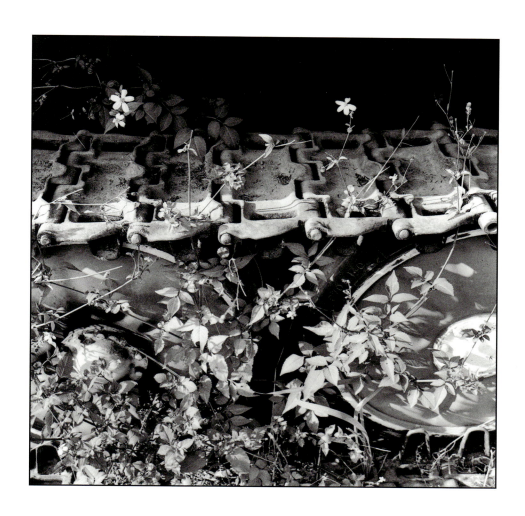

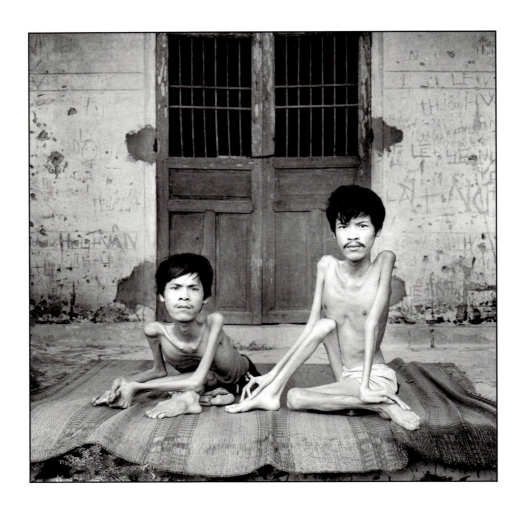

Sons of a man poisoned by Agent Orange

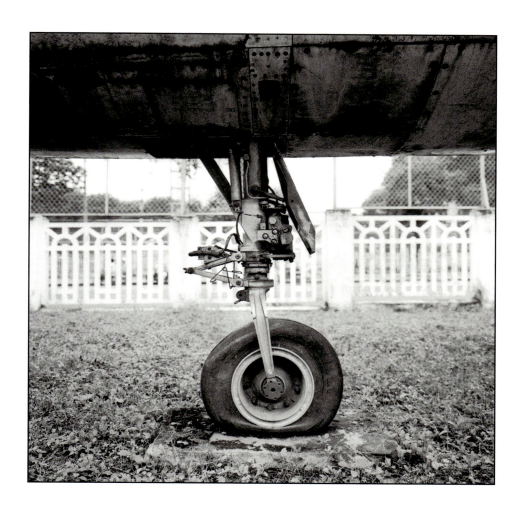

Jet-bomber nose-wheel

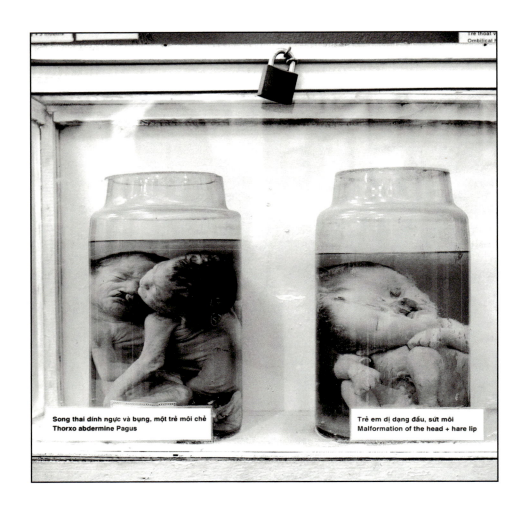

Agent Orange foetuses

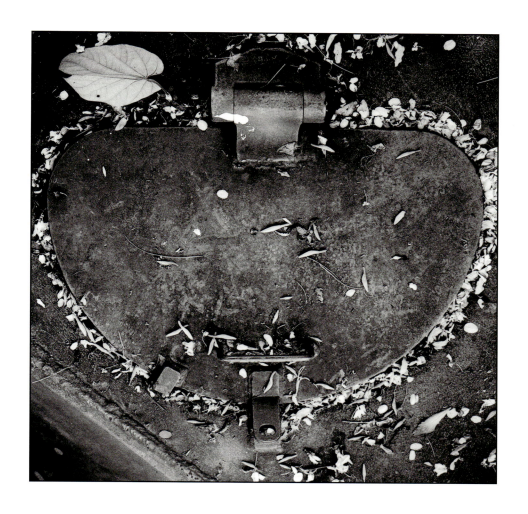

Tank hatch

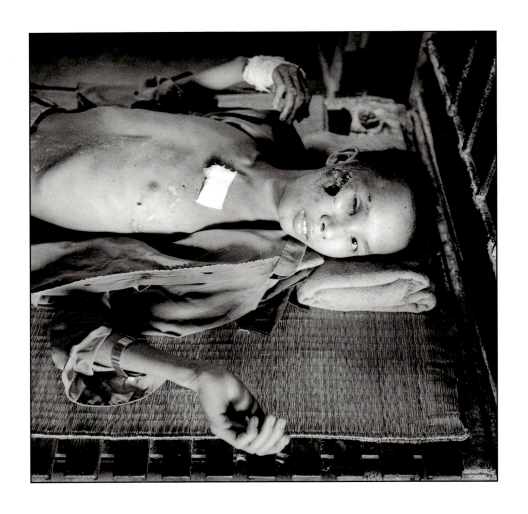

Unexploded bomb

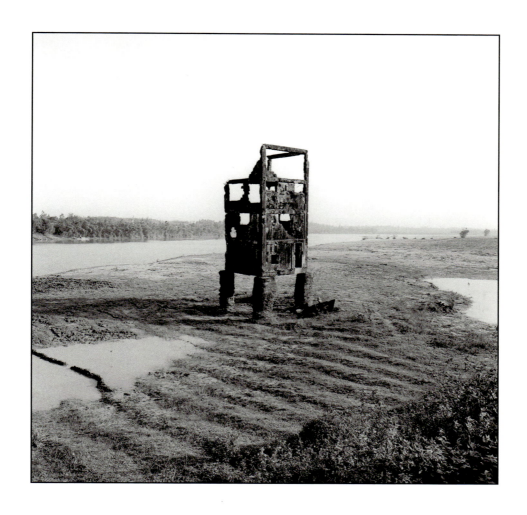

Destroyed watchtower

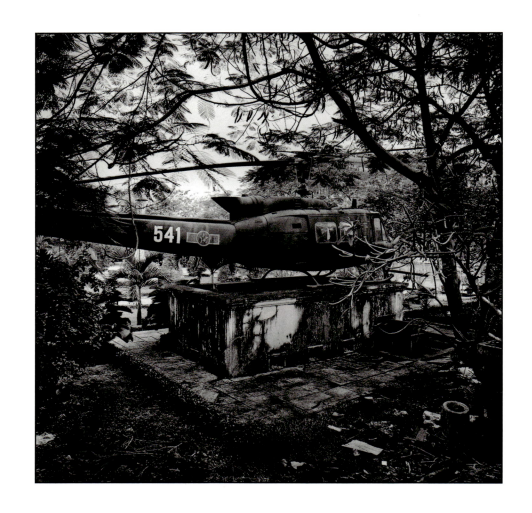

The last Huey

Tourist trinkets

Underside of a bomber

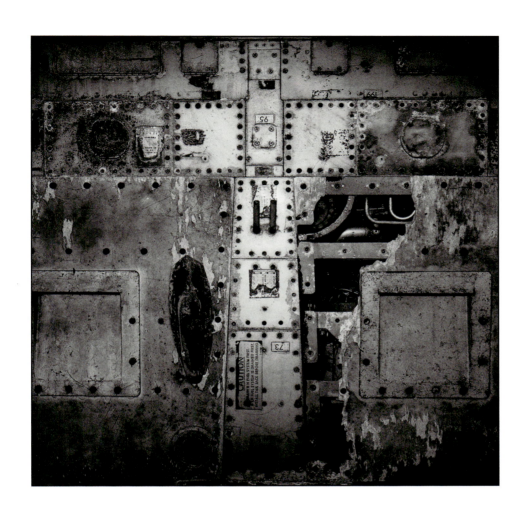

Auschwitz
'This necropolis of human hope'

The museum at Auschwitz, in the small Polish town of Oświęcim, contains the physical remains, mostly as ash, of 1.15 million people. The victims included, amongst others: homosexuals, Jehovah's Witnesses, Soviet POWs, ordinary criminals and Poles. It is however, best known as the final resting place of perhaps a fifth of the six million Jews killed by the Nazis during the Holocaust. It is less well known as the sight of the genocide of Romani people (the 'Gypsies') known as the Porrajmos.

This is the biggest cemetery in the world. At their height, the gas chambers consumed 24,000 per day - so many that the crematoria could not keep up and bodies were burnt outdoors. Auschwitz was also a prison of slave labourers with a population at its peak of 150,000 - equal in size to Tangiers or Aberdeen.

After the war, a death camp commandant answered an interviewer's questions:

"Would it be true to say you got used to the liquidations?"

He thought for a moment. "To tell the truth," he then said slowly and thoughtfully, "one did become used to it."

[...] "So you didn't feel they were human beings?"

"Cargo," he said tonelessly. "They were cargo."[1]

This cargo is now missing, leaving only tragic remnants: "Armless sleeves, eyeless lenses, headless caps, footless shoes: victims are known only by their absence, by the moment of their destruction."[2]

Crematoria

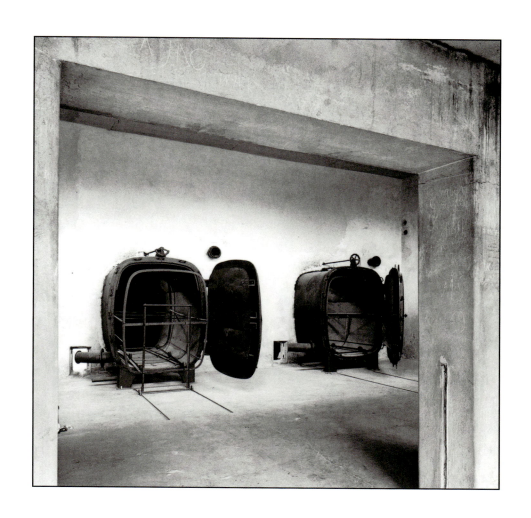

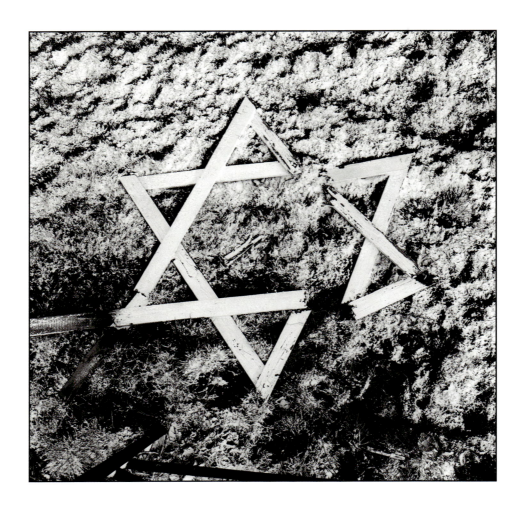

Markers where ash has been found

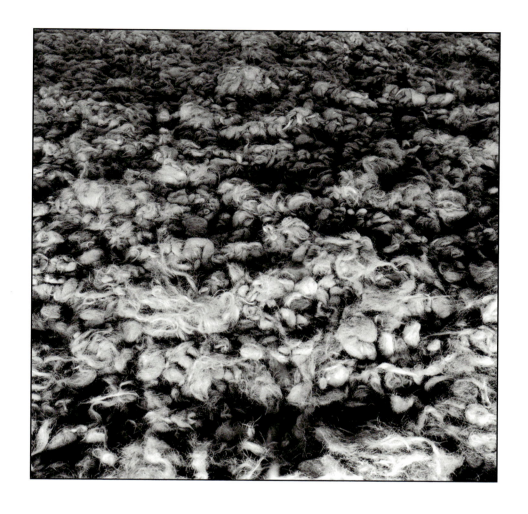

7000kg. of women's hair

Small, 700 person gas chamber

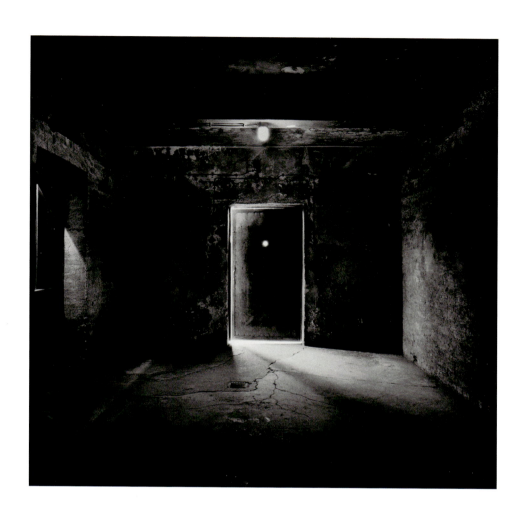

Gas canisters

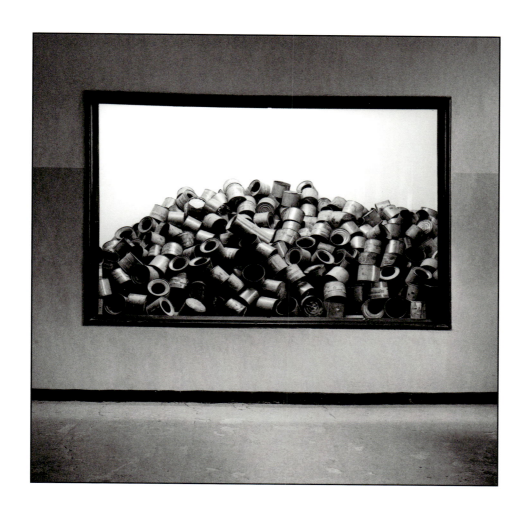

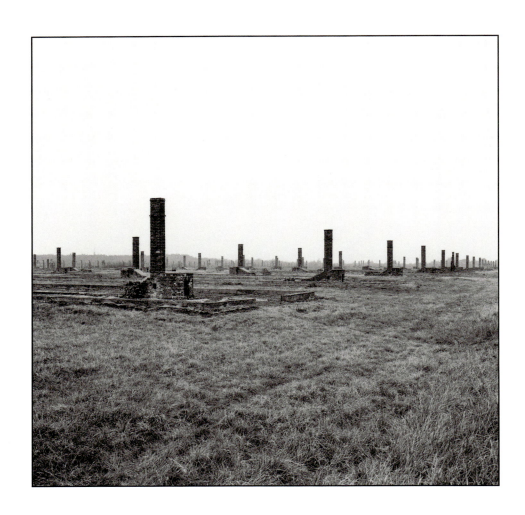

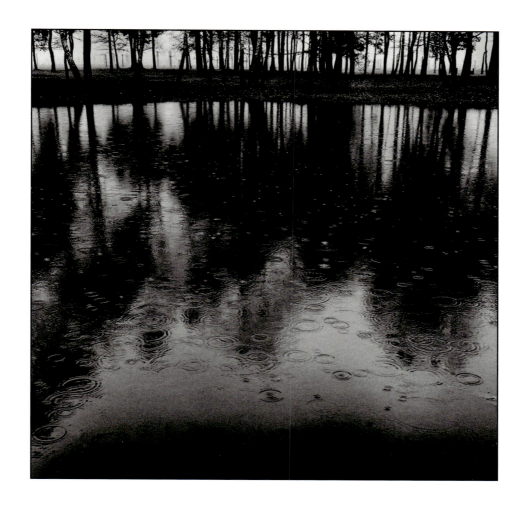

Ash pond

Where 'selections' were made

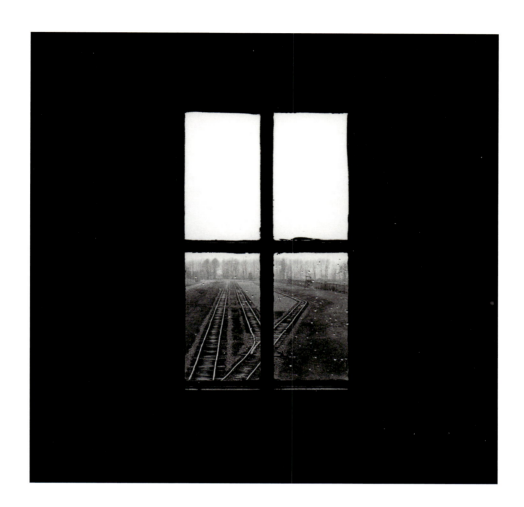

Gas chamber ruins

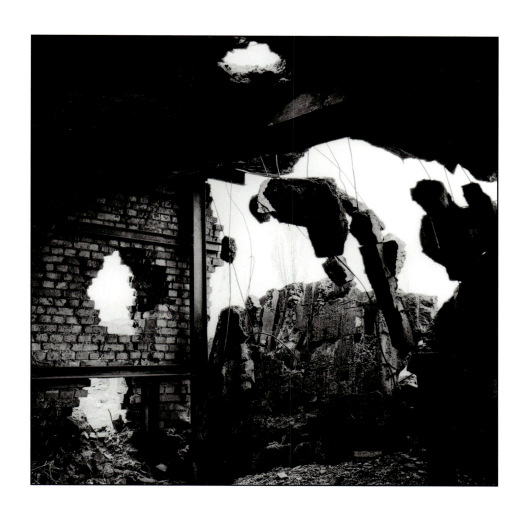

Prison staircase

Dresden
'With fire and sword'

The Royal Air Force annihilated the city of Dresden and its inhabitants on the night of 13/14th February 1945. Whilst this was not 'genocide' in the true sense of the word, it is included here to show how easily the ability to kill can outstrip any justification for killing. Dresden had not been bombed earlier in the war because there was virtually nothing there worth bombing. By 1945, it became a target simply because bombers and pilots were available. As Churchill put it, "it is absurd to consider morality on this topic… In the last war, bombing of open cities was regarded as forbidden. Now everybody does it as a matter of course. It is simply a question of fashion, changing as she does between long and short skirts for women."[1]

And in this fashion 35-40,000 German civilians lost their lives. Of this total, less than 100 were German soldiers. No military purpose was served other than to intimidate and impress the Russians who were advancing from the East.[2]

With the war drawing to a close and with nothing better to do, Bomber Command under Sir Arthur Harris, was allowed to return to his hit-list of the top 60 German cities, and get on with eradicating them. He boasted that his personal best was two and a half a month. 'Bomber' Harris did not believe in 'precision' bombing or the targeting of key economic lynch-pins such as oil or ball-bearings or the destruction of transport hubs. Harris believed in one technique only; night bombing by fleets of heavy bombers – a method so crude that the only object big enough for it to hit, was an entire city. Bombs were 'on target' if they were within three miles of the aiming point. Even the official history of the RAF was aghast; "The destruction of Germany was on a scale which might have appalled Attila or Genghis Kahn."[3]

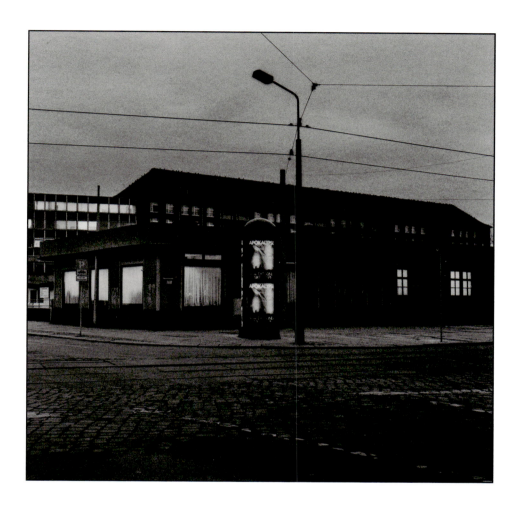

Aiming point for the second wave

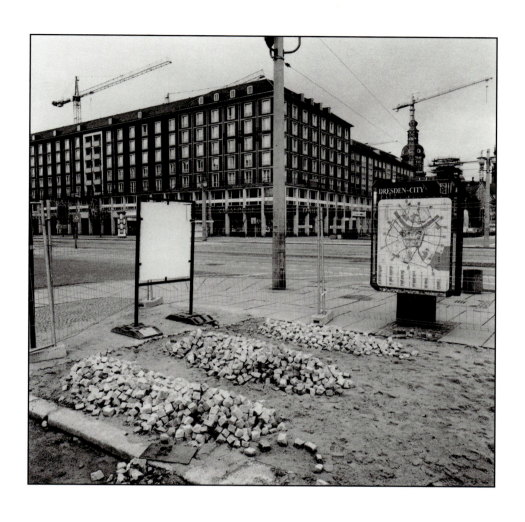

Air-raid shelter

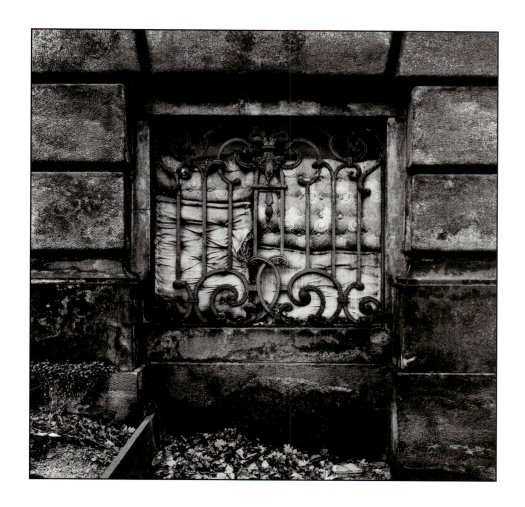

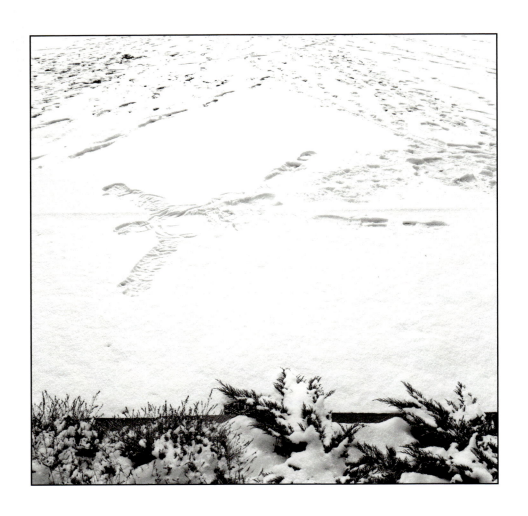

Cemetery for ash remains

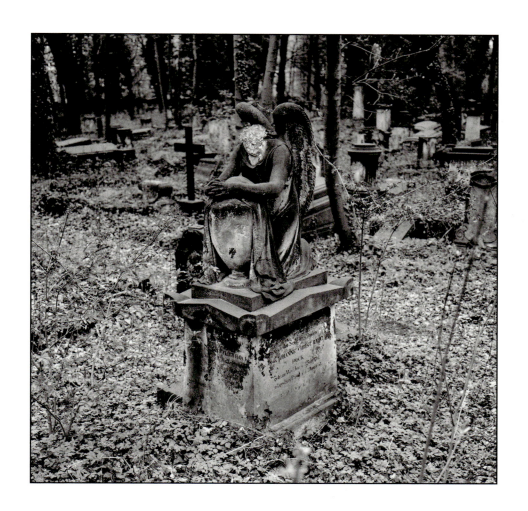

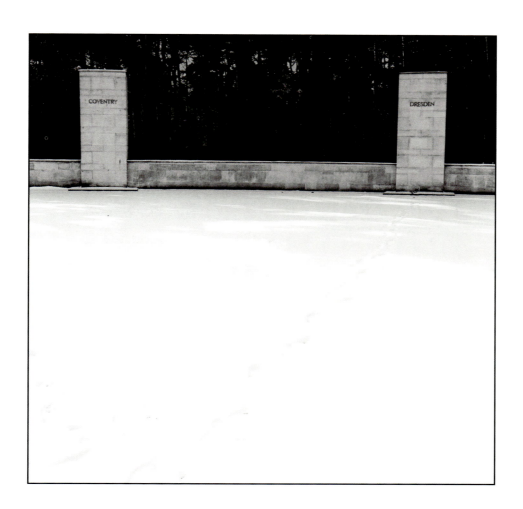

Repaired cherub

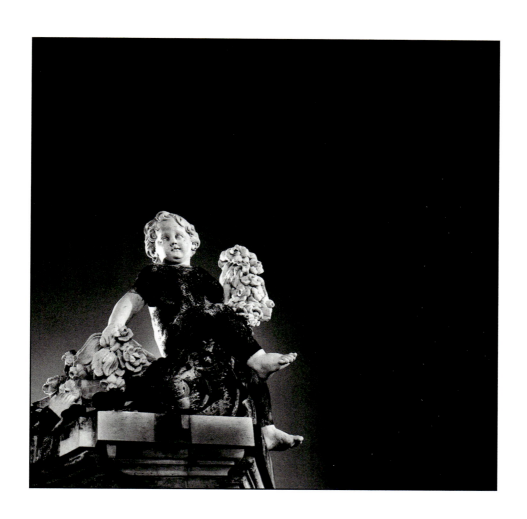

Augustus, Dresden's founder

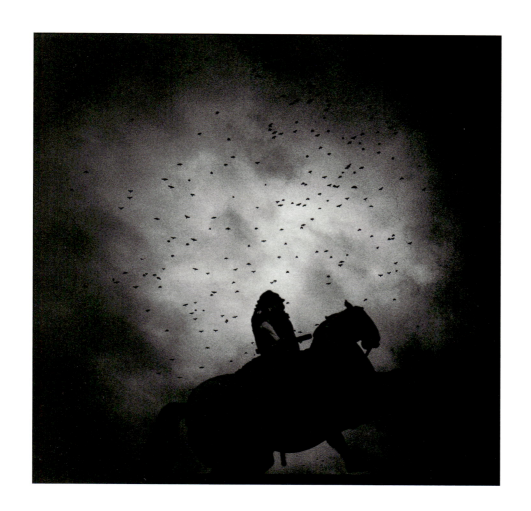

Coventry straße

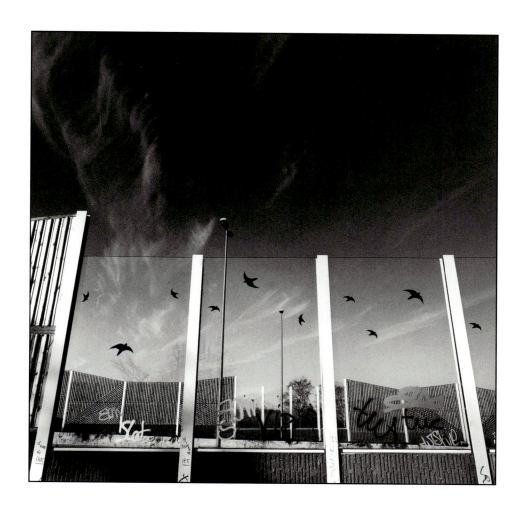

Ukraine
'A melancholy desert'

The famine in the Ukraine, which raged during the winter and spring of 1932/3, was entirely avoidable. It was not caused by poor soil or drought or inefficient transport. It was planned – the Ukrainians call it 'Shtuchnyi Holod' the man-made famine. The Ukrainian countryside possessed the Soviet Union's largest and most turbulent ethnic minority which was, at the same time, its richest and most self-reliant peasantry. In the Famine, with one blow Stalin destroyed Ukrainian nationalism and the class of wealthy farmers – the 'kulaks.' The tools of this genocide were the collectivisation of agriculture and massive removal of all food crops from the countryside. Unrealistically high levels of grain appropriation went to fuel the Five Year Plan leaving no seed for the next season and no food to feed the peasantry.

Stalin's original intention was probably no more than the meeting of grain production targets, but as the Famine took hold, he saw beneficial, if unforeseen, consequences: – increased class consciousness among the poorer peasants as the kulaks were denounced; the destruction of social strata most resistant to collectivisation, without which the State could never really control food supplies; and finally, the eradication of those most likely to support Ukrainian nationalism. Knowing that millions were starving, he ordered even more extensive seizures of grain. The majority of deaths took place far from public eyes with peasants simply wasting away in their hovels and can only be approximated at somewhere close to 6 million over a period of nine months.

In 1932, fields had armed guards

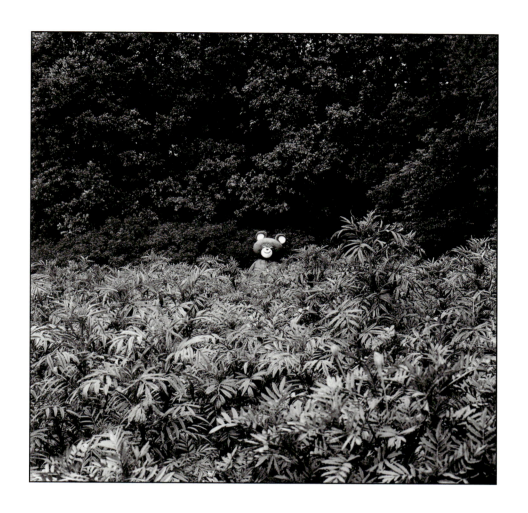

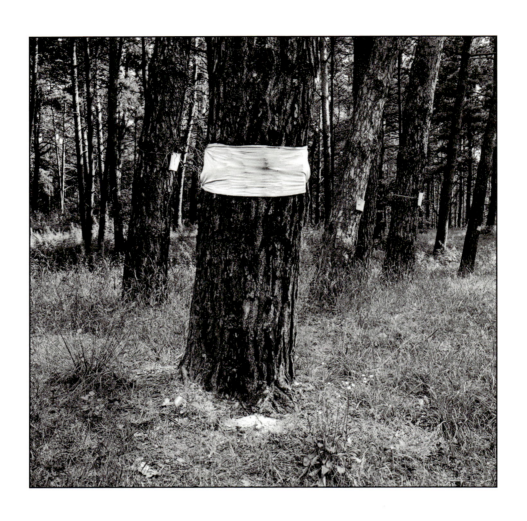

Scene of mass shootings

Tourist dolls

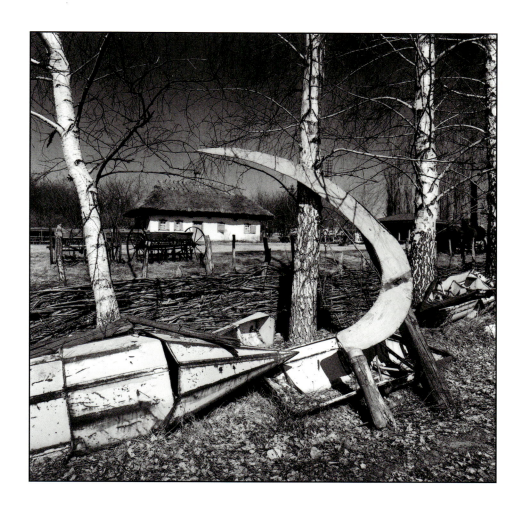

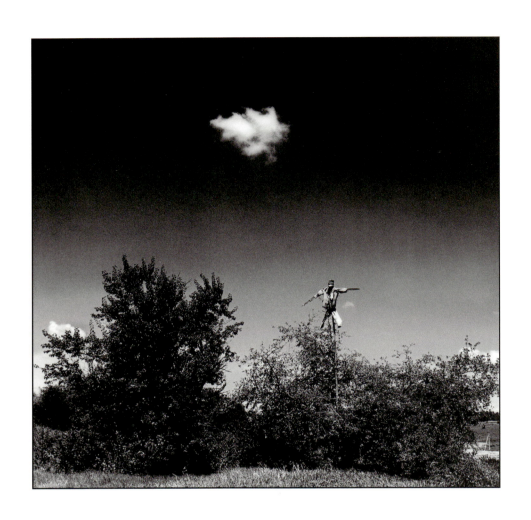

Hawk scarer

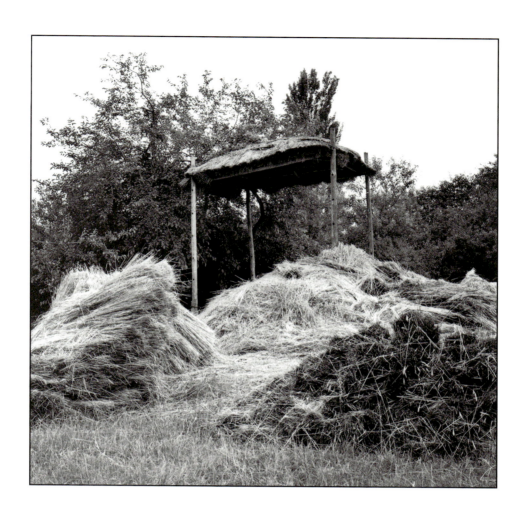

Sunflowers

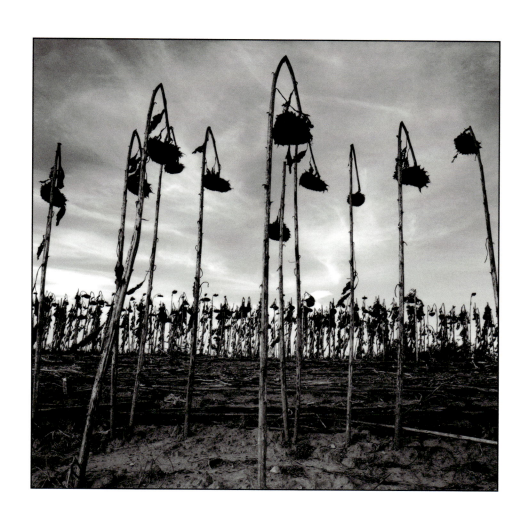

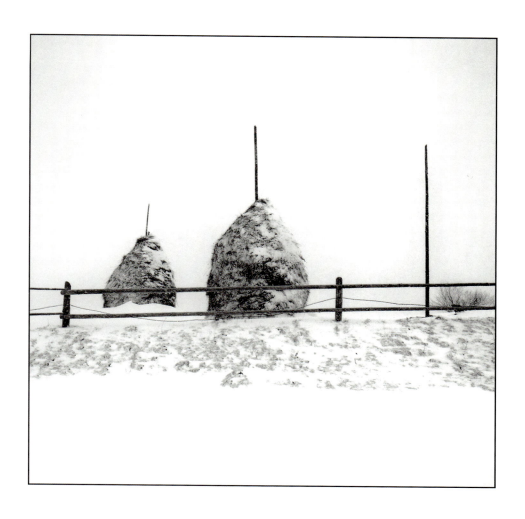

Woodpecker's nest

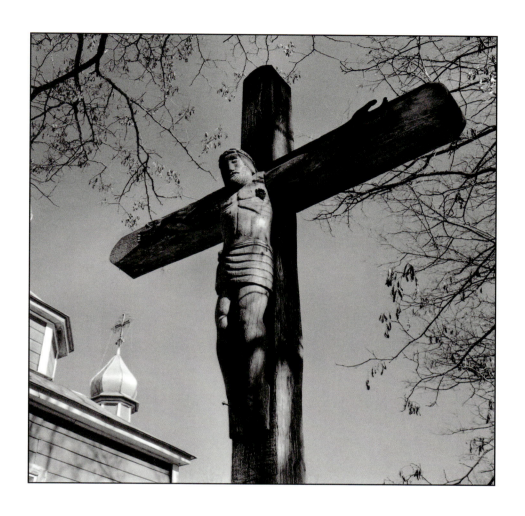

Armenia
'After all, who now remembers the Armenians?'

In 1915, the Turkish government killed about 1 million members of the Armenian minority in Turkey. The Young Turk leaders, Talaat, Enver and Jemal, were driven by a bizarre racist fantasy of reconstructing a vast empire uniting all those who spoke languages with Turkic roots, stretching from Bosnia to China. Their role models were Tamarlaine, Attila and Genghis Khan. It was the misfortune of the Armenians, who were not Muslims and did not speak Turkish, that the land they had historically occupied lay in the centre of this Pan-Turkic myth. On April 23rd 1915, co-ordinated by telegraph, the genocide began. Men and boys were gathered together and butchered. Women and children were driven in long convoys down from the mountains to concentration camps in the deserts of what is now eastern Syria where they died of thirst, exhaustion and heat stroke.

To this day, the government of Turkey denies that what happened in 1915 was genocide, and wishes instead that this crime was forgotten. But some observers have been keen to learn from the Turkish example of thoroughness and cover-up. In persuading his generals of the proposed use of death squads in the Final Solution, Adolf Hitler asked, 'After all, who now remembers the Armenians?'

Scarecrow

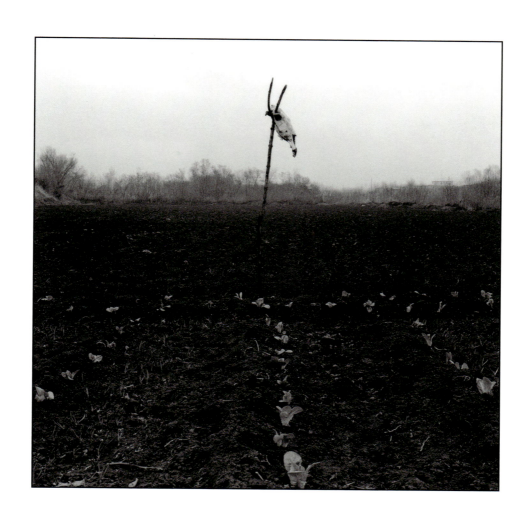

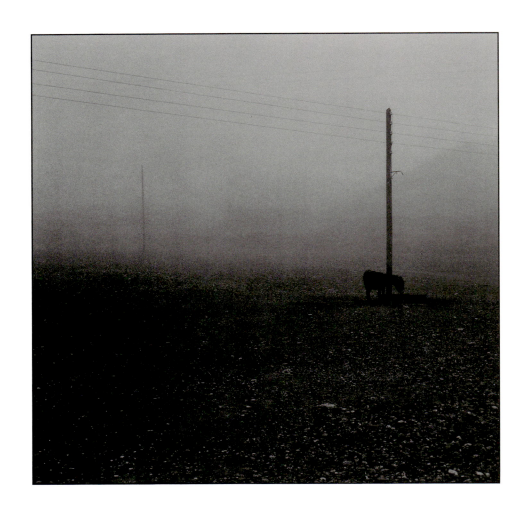

Donkey in a sandstorm

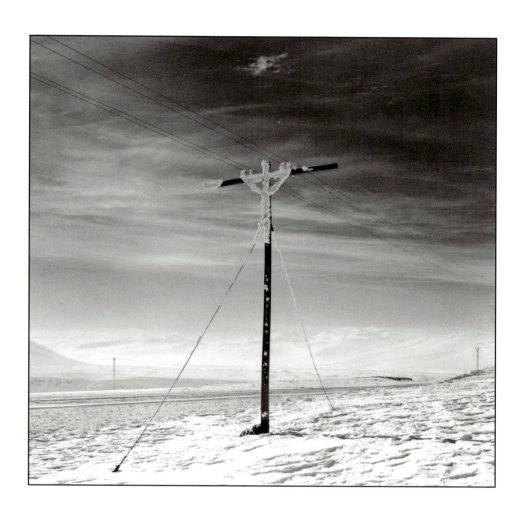

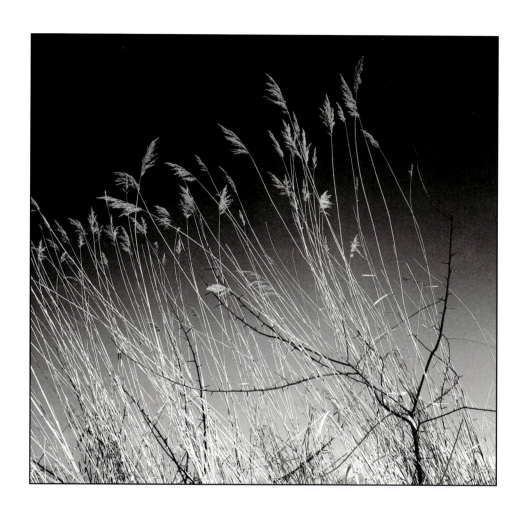

Fox tracks

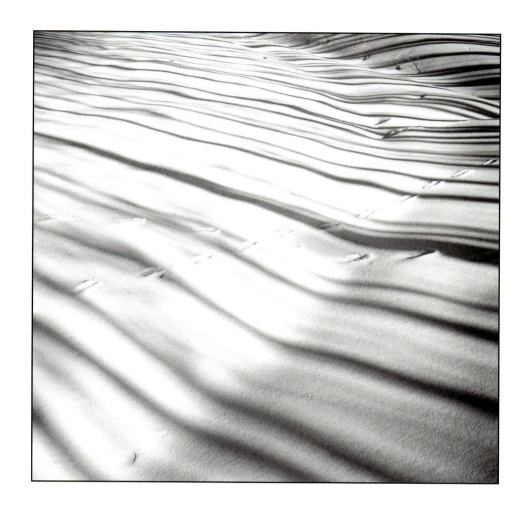

Melting snow

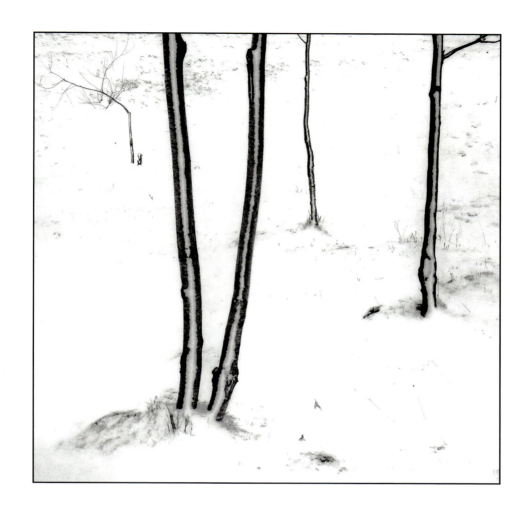

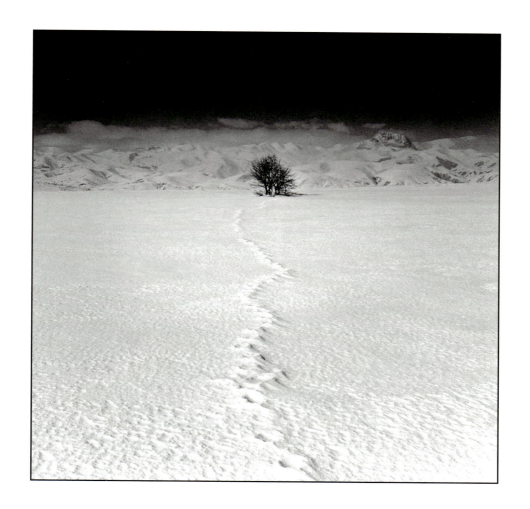

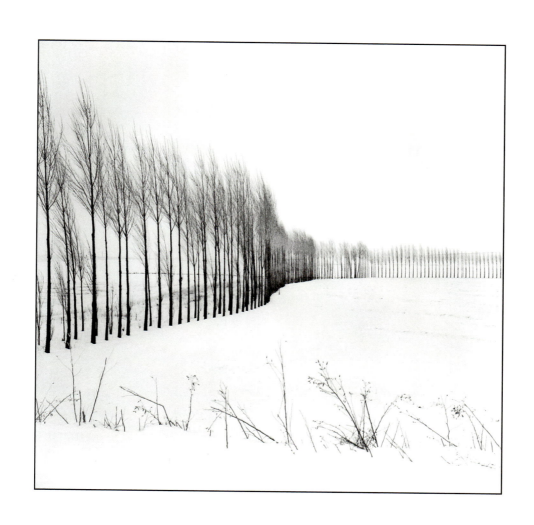

Exile

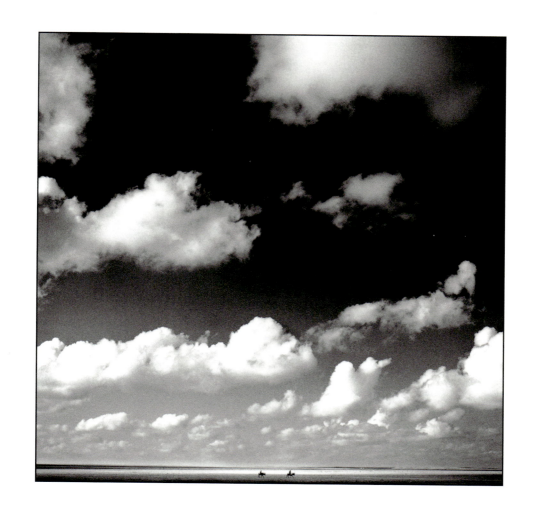

Namibia
'The sublime silence of infinity'

The Herero were a small tribe of nomadic cattle-herders living in the desert margins of what, at the beginning of this century was called German South-West Africa, present-day Namibia. For the Herero, German rule was a litany of broken treaties, land-theft, rape and murder. In January of 1904 the Germans began drafting plans to sell almost all their lands to white farmers and confine the Herero to "reserves." With no alternative, despite knowing they would be ruthlessly punished, the Herero rose up in rebellion.

The final battle was at the Waterberg in August of 1904. The warriors were crushed in combat and the defeated survivors, women and children were driven from the last of their waterholes into the vast Omaheke desert. The Germans established armed camps to seal the desert's edge, with cavalry units pushing the Herero far into the waterless wilderness. Death by dehydration was slow, and merciless. German patrols found corpses around 15 metre deep hollows in the ground where the dying had dug in vain to reach the groundwater. Only a handful avoided capture, and of the 15,000 prisoners taken by the Germans, half died from maltreatment before the end of the Uprising. Fully 80% of the Herero nation met an agonizing death in the arid sandveld.

The Herero almost never talk about what happened in the Omaheke. When gently questioned in 1907 by a German missionary, a Herero woman answered, "The wind has blown sand over the tracks and tears; one cannot narrate how it was." Then she covered her face and wept.[1]

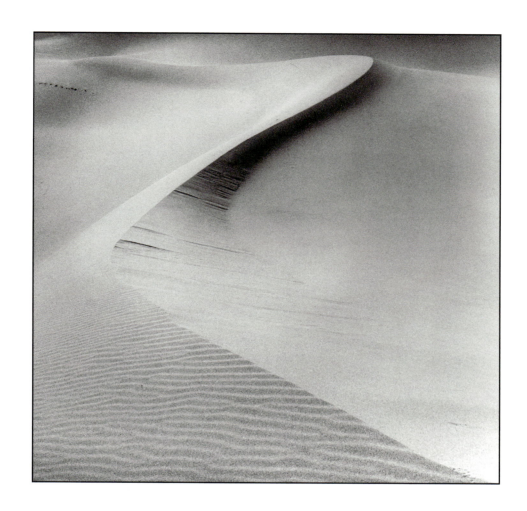

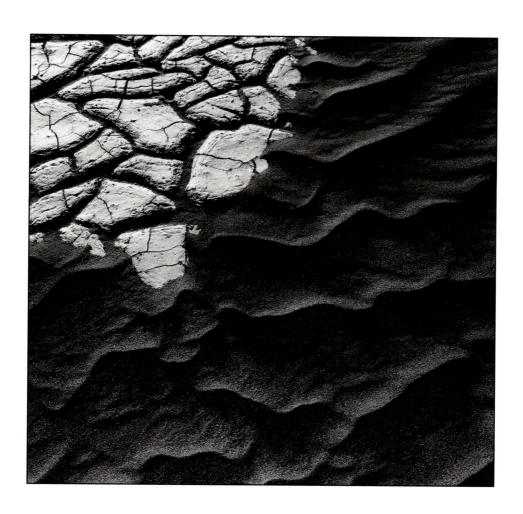

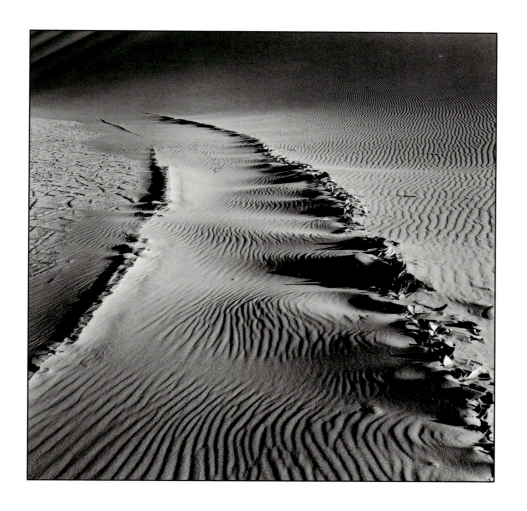

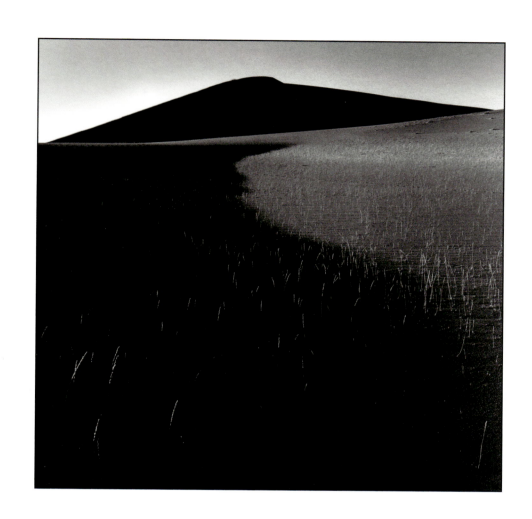

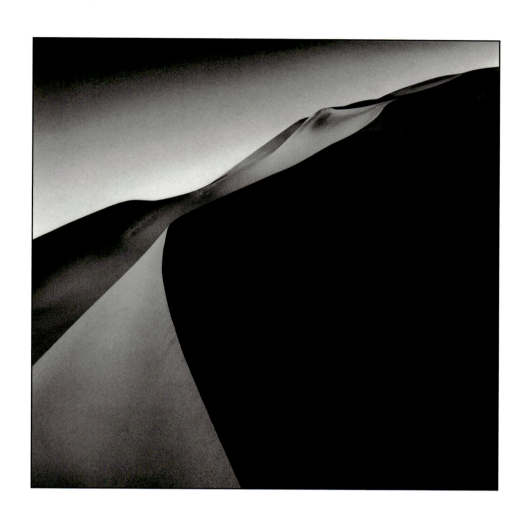

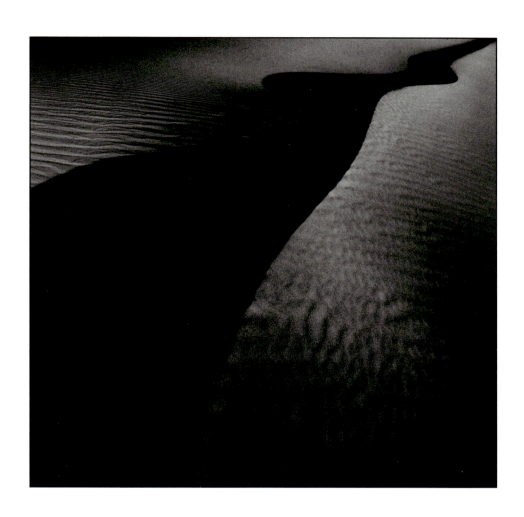

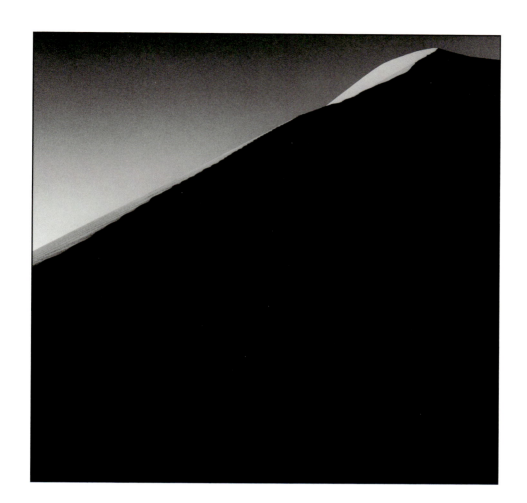

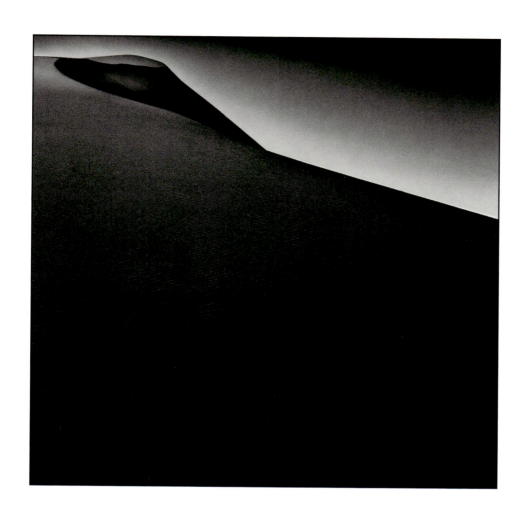

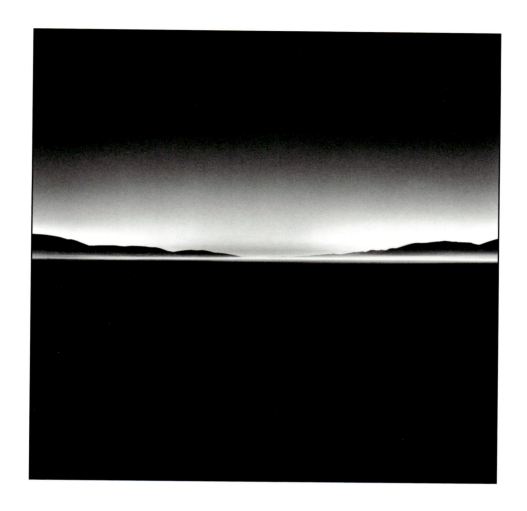

At the end of his report on
Buchenwald, the distinguished
American broadcaster
Edward R. Murrow said:
"I pray you to believe what I have
said about Buchenwald.
I have reported what I saw and heard,
but only part of it.
For most of it I have no words."

Sylvestre Gacumbitsi, bourgmestre of Rusomo commune, was well organised. When the killings started he assured the public that, as mayor, he would ensure their safety. He gave those who were frightened passes to allow them access to Nyarubuye church. Having gathered all the local Tutsi there, he had no problem finding those he wanted to kill. He sent the militia to the church and they slaughtered 2,620 people on 15 April 1994. This classroom is in the school buildings behind the church.

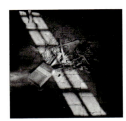

In Nyarubuye church. Hutu propaganda said that the Tutsis were originally from Ethiopia and that the best way to return them was by throwing their corpses into the rivers that flow eventually into the Nile. Failing that, bodies were disposed of into whatever water was available, usually pit latrines. Here a boy's legs were cut off and pushed into the vase that had been on the altar. The 'vase' was originally Canadian food aid.

The skull of a child. "The dead lie on either side of the pathway. A woman on her side, an expression of surprise on her face, her mouth open and a deep gash on her head. Stepping over the corpse of a tall man who lies directly across the path, and, feeling the grass brush against my legs, I look down to my left and see a child who has been hacked almost into two pieces. I cannot tell if it is a girl or a boy. I begin to pray to myself, "Our Father, who art in Heaven…" These are prayers I have not said since my childhood but I need them now." – The BBC's Feargal Keane. [2]

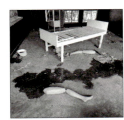

Destroyed infirmary of St André's College. "What they left behind is indescribable. I can never forget the scene when we came out [from hiding] – the wounded howling in pain, the sight of people frantically searching for relatives, children sobbing over their dead fathers and brothers. There were male bodies everywhere - bayoneted, macheted, speared and knifed to death. We looked and saw that the people that we had just shared our lunch with were dead. [5]

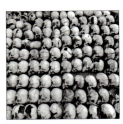

The skulls of bodies found around the church at Ntarama, brought together at the beginning of the process of building a memorial. The government controlled Radio Mille Collines broadcast in April of 1994, "The grave is only half full. Who will help us fill it?"

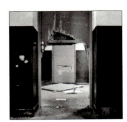

The door to a teacher's office in the destroyed St. André's College, Nyamirambo, Kigali. Thousands of Tutsis sought safety in numbers at the school, although when they were eventually discovered the killing was wholesale and merciless. When the Hutu militia attacked they called it 'Muyaga,' – 'the wind that blows itself into a hurricane.'

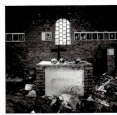

The altar of the church at Ntarama. The church has been left in a chaotic state, partly as a memorial and partly because it makes good propaganda for the new government. One survivor, Beata Niyoyita reported that the Interahamwe included "women and young boys, about 11-14, carrying spears and sharpened sticks. They used these to beat a lot of children to death." [3]

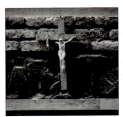

In one of the chaotic classrooms at Nyarubuye church where frightened Tutsi had sought refuge and were hunted down. Whilst some priests did their best to defend their flock, the Catholic Church has been fatally compromised by the behaviour of the majority. A vital prop for the old regime, many priests were among the killers or used the genocide as cover to extract sexual favours or money.

Leoncia Mukandayambaje is one of only eight survivors of the massacre at Nyarubuye. The militia chased the victims out of the nave and into a courtyard. They raped ten of the women. They are still lying there now, with their knickers around the knees of their rotting skelketons. Leoncia was saved by the daughter she held on to. The militia hacked at the baby so much that its blood covered Leoncia and the killers assumed both mother and daughter were dead. But only the baby was. "I only live with sadness," said Leoncia. [4]

Fierce fighting around the Parliament building wrecked the neighbourhood. Each of the extremist Hutu political parties, The MRND and CDR had vicious, militant youth-wings called MRND-Power (the Interahamwe) and CDR-Power (the Impuzamugambi.)

1 'Rwanda: Death, Despair and Defiance.' African Rights, London. 1994 p.455
2 Fergal Keane, 'Season of Blood: A Rwandan Journey.' Harmondsworth 1995 p.78
3 'Rwanda: Death, Despair and Defiance' p.210
4 Mark Huband, The Observer newspaper, London 2nd May 1995 p.14
5 Survivor Eugène Byusa, 'Rwanda: Death, Despair and Defiance' p.297

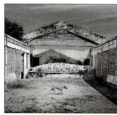
A former teacher's training college at Suong Tonlé Bati, Takeo province. To have an education or to be caught wearing glasses or speaking a foreign language, was to be labelled as 'poisoned by foreign influences,' and resulted in death. The Khmer Rouge turned this building into a prison and execution centre. After the fall of the Khmer Rouge, local people unearthed these skulls and placed them on the stage in what had been the assembly hall.

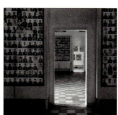
By the time the invading Vietnamese army overthrew Pol Pot in January 1979, up to 20,000 people had gone through S-21. The prison and, by extension, its techniques, had a near 100% record - only 7 inmates were ever found innocent and released. All others confessed, all were put to death. The Khmer Rouge photographer Nhem Ein recalled the conveyor belt of faces, "filled with fear and deep sadness." [4]

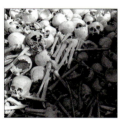
Pictures shot by Khmer Rouge photographers for party leaders as proof of death. The prison compound at Tuol Sleng was known as a place 'where people go in but never come out.' Torture was almost routine – the tormentors would often continue until the victims, sometimes illiterate peasants, had confessed to being Grand Spymasters of both the CIA and the KGB. Acres of meaningless 'confession' would be dutifully typed up and sent to the Party centre where it would be used to justify further purges.

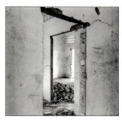
Former prison at the monastery of Phnom Srei, Kompong Cham Province. The Khmer Rouge destroyed organised Buddhism, declaring it utterly incompatible with the revolution. Out of a total of 2,680 monks from eight of Cambodia's monasteries, only 70 were found to have survived in 1979. As one leading Khmer Rouge put it, the monks had "left the temples…The problem gradually becomes extinguished. Hence there is no more problem." [5]

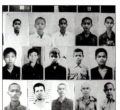
"Everywhere the human soul stands between a hemisphere of light and another of darkness." – Thomas Carlyle. The communist Khmer Rouge executed entire families because they defined social class and political background as near-biological traits. A top official wrote: "It is possible that some compositions can correct themselves, but many of them cannot. If they die, they will have instructed their children to keep struggling against the communists." [2] Families were split up and 'Familyism,' the Khmer Rouge term for missing one's loved ones, became a crime, punishable by death. [3]

The bed of a torture victim at Tuol Sleng and, above, a picture of the victim as he was discovered when the prison was liberated. "They told us we were void. We were less than a grain of rice in a large pile. The Khmer Rouge said that the Communist revolution could be successful with only two people. Our lives had no significance to their great Communist nation, and they told us, 'To keep you is no benefit, to destroy you is no loss'." [6]

Portraits of Party activists condemned to death. The civil war and massive American bombing of Cambodia created tens of thousands of orphans, many of whom were taken in by the Khmer Rouge and turned into some of their most brutal and merciless cadre. After the purges of 1977 many ended up in the cells at Tuol Sleng Prison in Phnom Penh, code-named S-21, and now preserved as a Museum of the Genocide.

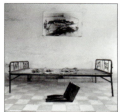
Graffiti on the wall of a building used by the Khmer Rouge as a prison. The Higher Organisation, 'Angkar Leu,' was said to have 'as many eyes as a pineapple,' Three separate accusations that someone was a member of the CIA was sufficient cause for arrest. The photographer who worked in one of the prisons recalled the torturers worked shifts amidst 'the constant cries and screams.' [7]

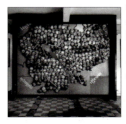
The Killing Fields of Choeung Ek, on the edge of Phnom Penh. Signposts at vague hollows in the ground read: "Mass grave of 166 victims without heads." Bullets were considered too precious for traitors, most were clubbed to death or suffocated with plastic bags. Children were battered against trees.

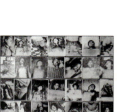
With the help of advisors from East Germany and Vietnam, S-21 has been turned into a museum of Khmer Rouge atrocities. The map was made using skulls from nearby mass-graves.

1 Sophiline Cheam Shapiro in 'Children of Cambodia's Killing Fields: Memoirs by Survivors.' Yale 1997 p.2
2 Frank Chalk, 'Redefining Genocide.' in 'Genocide: Conceptual and Historical Dimensions,' edited by George J. Andreopoulos, Philadelphia 1994 p.51

3 Ben Kiernan, Introduction to 'Children of Cambodia's Killing Fields' ibid. p.xii
4 As told to Robin McDowell of the Associated Press, The Telegraph magazine, London 21st Feb. 1998
5 Ben Kiernan, 'The Cambodian Genocide: Issues and

Responses' in Andreopoulos, ibid. p.197
6 Teeda Butt Mam, 'Children of Cambodia's Killing Fields' ibid. p.12
7 David P. Chandler, 'Brother Number One: a Political Biography of Pol Pot.' Chiang Mai 1992 p.155

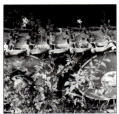

Vietnamese Air Force Museum, Hanoi. In 1962, General Anthis of the American Air Force devised the 'free bombing zone' system as "yet another way to generate targets and keep his pilots busy…[they delineated] specific zones of guerrilla dominance in which anything that moved could be killed and anything that stood could be levelled." [1]

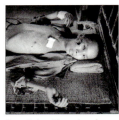

Bui Minh, 27 years old, was planting eucalyptus trees in 1996, near what used to be Con Thien Firebase when his spade hit an unexploded shrapnel round. He was extensively wounded in the face and chest and lost one eye. Photographed in Quang Tri Provincial Hospital, which still receives one such victim every fortnight. Even by the optimistic American assessment, they left behind 150,000 tons of unexploded bombs lurking in the Vietnamese soil.

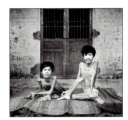

Nguyen Cong A (24) and his brother Ta (21) in the hamlet of An Loi, Quang Tri province. During the war, their father Oanh was in the Vietnamese army allied with the Americans when his platoon was accidentally sprayed with Agent Orange defoliant. After capture and two years re-education in the North, he returned to his fishing village on the coast to father two sons, both victims of congenital deformities.

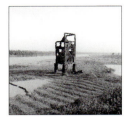

General William DePuy set himself apart from his fellow generals by turning firepower loose with even more abundance than they did. When asked about how he would wield the world's most sophisticated war machine, he made his famous prediction, "We are going to stomp them to death," and added, almost as a kind of confession, "I don't know any other way." [5]

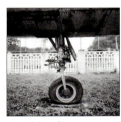

Nosewheel of an F-5E fighter-bomber. Military Museum, Ho Chi Minh City. "We turned back to the father and we said, 'So you got [a tin of] pears. GI's are nice enough to give them to you.' All the Vietnamese carried this big old plastic ID card with a picture on it that says they are okay in the Republic of Vietnam. So we ripped up the ID card. 'Hey, we got a VC here, fellas! A VC stealing government stuff, huh?' We shot him. Like I said, we was in a free fire zone." [2]

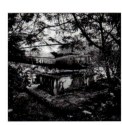

UH-1 'Huey' helicopter, Revolutionary Museum, Ho Chi Minh City. By 1968, the level of 'accidental' civilian deaths was 25,000 per year and 85,000 injured. Fifteen million tons of ordnance was dropped on Vietnam, more than three times the total dropped in all the theatres of World War Two. Ten million were made homeless. Robert McNamara, the Secretary of State for Defense wrote, "I never thought it would go on like this. I didn't think these people had the capacity to fight this way… to take this punishment." [6]

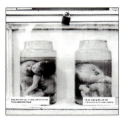

Museum of the American War Atrocity, Ho Chi Minh City. In an attempt to deny jungle cover to the enemy, 72,000,000 litres of defoliants were sprayed over the forests and fields of South East Asia, during the nine year-long Operation Ranch Hand. The herbicide of choice was the deadly Agent Orange containing the virulent poison 'dioxin' that causes liver cancer and birth defects. The rate of natural abortions, which was 0.45% in 1952, reached a peak of 18.14% in 1968. [3]

"You can't tell who's your enemy. You got to shoot kids, you got to shoot women. You don't want to. You may be sorry that you did. But you may be sorrier if you didn't. That's the damn truth." [7] "I have to admit I enjoyed killing. It gave me a great thrill while I was there. My attitude was: the less of them there were, the better my chances of making it…There was a certain joy you had in killing, an exhilaration that is hard to explain." [8]

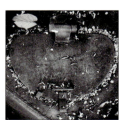

Tank hatch and laburnum petals, Revolutionary Museum, Ho Chi Minh City. Army Field Manual 27-10, "The Law of Land Warfare," which interprets the Hague and Geneva conventions that are legally binding on the US military, enjoins officers to "conduct hostilities with regard to the principles of humanity and chivalry.' Leading American General, William DePuy's interpretation of this was, "The solution in Vietnam is more bombs, more shells, more napalm… till the other side cracks and gives up." [4]

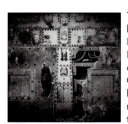

The underside of a 'Tiger' fighter bomber. Revolutionary Museum, Ho Chi Minh City. The journalist Neil Sheehan asked the commander of the US Forces in Vietnam, General William Westmoreland "if he was worried about the large number of civilian casualties from the air strikes and the shelling." The general looked at him carefully and then replied, "Yes, Neil, it is a problem, but it does deprive the enemy of the population, doesn't it?" [9]

1 Neil Sheehan, 'A Bright Shining Lie.' London 1990 p.540
2 Mark Baker, 'Nam.' London 1987 p.149
3 'Herbicides and Defoliants in War: The Long Term Effects on Man and Nature.' Vietnam Courier, Hanoi, 1983
4 In conversation with the Chicago Daily News. Sheehan, ibid. p.619
5 Sheehan, ibid. p.568
6 Paul Elliott, 'Vietnam: Conflict and Controversy,' London 1996 p.91
7 Baker, ibid. p.151
8 Baker, ibid. p.144
9 Sheehan, ibid. p.621

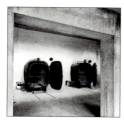

"It is not easy to burn bodies, particularly emaciated bodies. The first attempts, long before the crematoria had been built, had used up a lot of scarce coke. The Nazis therefore conducted a series of experiments to find out how to save fuel. They soon found that if a fat man was burned along with a thin one, the fat man's fat would serve as fuel to consume the thin one. In due time, they discovered a still more efficient combination: a fat man and a thin woman (or vice versa) and a child." [3]

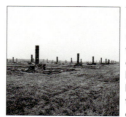

The brick chimneys of wooden barrack blocks, burned by the SS upon their departure. Those who were fit enough to be selected for death through overwork, rather than being immediately gassed, would be greeted by the camp guards with the words, 'This is Auschwitz, the only exit is via the chimney.'

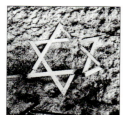

"The following question has been put to us: what is to be done with the women and children? I have taken a decision…I did not feel I had the right to exterminate the men – say, if you like, to kill them or to have them killed – and to allow the children to grow up and to avenge themselves on our children and descendants. It was necessary to take the grave decision to make this people disappear from the face of the earth." [4]

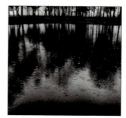

"Just beyond the site of Crematorium IV, hidden by a stand of tall elegant birch trees, is a small pond. It is a tranquil place where frogs loll in the green algae on the surface and overhead the leaves of the birches rustle in the wind… I reach into the water and bring up a dense, sticky mass of clay, enough to cover two fingers. It contains three small, white fragments, bits of bones of human beings who were incinerated in the coke-fired crematory ovens, and whose ashes were dumped by the wheelbarrow-load into these still waters." [7]

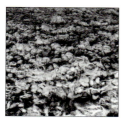

"A brisk trade emerged between [Auschwitz] and German felt and textile manufacturers who used the versatile fibre in the production of thread, rope, cloth, carpets, mattress stuffing, lining stiffeners for uniforms, socks for submarine crews and felt insulators for railway workers. The hair was shorn and then 'cured' in lofts over the crematoria ovens…The 20kg bales [of hair] were marketed to German companies at twenty pfennigs a kilo." [5]

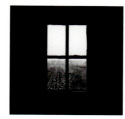

"What kind of civilisation produces Auschwitz and Beethoven? Or more pointedly: an orchestra of slaves that plays Beethoven as thousands are incinerated?" After a hard day at the selection ramps deciding who was to die, the Commandant of Auschwitz, Josef Kramer, returned to his barracks and, to relax him, ordered the camp orchestra to play Mozart. The Commandant closed his eyes letting the music wash over him and he became quite tearful. "How beautiful, how moving." he murmured. [8]

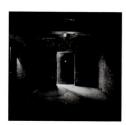

Telegram from Auschwitz to the central economic administration at Oranienburg, 8/Mar/43; "Transported from Breslau, arrived 5/Mar/43. Total: 1405 Jews. Put to work: 406 men and 190 women. Subjected to special treatment: 125 men and 684 women and children."

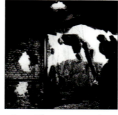

"The Jewish Question in the countries occupied by us will be settled by the end of this year… This is a page of glory in our history which has never been written and is never to be written." Heinrich Himmler, October 1943. The SS had plans to completely destroy Auschwitz in order to hide their crime. The camp only exists today due to the unforeseen speed of the Russian advance. As a result, the Germans only had time to burn some of the barracks and dynamite the gas chambers.

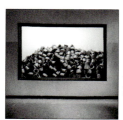

"Hydrocyanic (or prussic) acid is a powerful poison for the blood of all higher animals. The DL(50) [lethal dose in 50% of cases] for human beings is as high as 1mg/kg of body weight…common application is Zyklon B, a mixture of liquid hydrocyanic acid with chloride and bromide derivatives as catalytic agents and silica as a support… formula HCN – boiling point 25.6° Centigrade, density (Air=1) 0.93." [6]

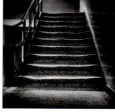

Auschwitz is the moral equivalent of Copernicus. All our ethical measurements need recalibrating now that we know it exists. All that we know about what people should do to each other; and what they might do to each other – all our innocence – has died now that the gas chamber has been introduced into the world of things. "Now the only visions of the world that can be taken seriously are those that come through the irrevocably ash-darkened prisms of post-Holocaust sense and sensibility." Our first epoch began with the Holocene and ended at the Holocaust. [9]

1 Franz Stangl, former commandant of Treblinka in Gitta Sereny, 'Into That Darkness,' London 1974 p.201
2 James E. Young. 'The Texture of Memory: Holocaust Memorials and Meaning.' Yale 1993 p.119
3 Otto Friedrich, 'The Kingdom of Auschwitz.' London 1996 p.70
4 Speech by Heinrich Himmler, Reichsführer SS 6th

Oct.1943. Quoted in Pierre Vidal-Naquet, 'Assassins of Memory: Essays on the Denial of the Holocaust.' New York 1992 p.12
5 Timothy W. Ryback, 'Bringing Auschwitz back to life.' The New Yorker, 15th Nov.1993 p.68
6 Winnacker and Weingaertner, 'Chemische Technologie – Organische Technologie.' Munich 1954

pp.1005-1006
7 Ryback, ibid. p.81
8 Gerald E. Markle, 'Meditations of a Holocaust Traveller.' New York 1995 p.27
9 G. Kren and L. Rappoport, 'The Holocaust and the Crisis in Human Behaviour.' New York 1980 p.143. Sven Lindqvist, 'Exterminate All The Brutes.' London 1997

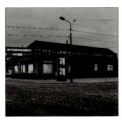

The city of Dresden – 'Florence on the Elbe' – was the capital of the kings of Saxony and as such, a treasure-house of elegant Baroque palaces and art galleries. Its biggest industry was the making of fine china and it possessed almost no war industry, military installations or anti-aircraft defences. A skilled propagandist, Harris said, "Dresden was a mass of munitions works, an intact government centre and key transportation centre. It is now none of these."

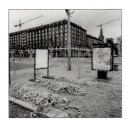

Dresden called for special measures from the RAF. A first wave of High Explosive bombs would blow the city open, then three hours later would come the second wave. Initial explosive bombs would kill the fire-fighters caught in the open to be followed by 670,000 incendiaries raining down to create the infamous 'firestorm;' a roaring, fiery whirlwind. Hundreds were burned in the 1000° inferno, but the majority asphyxiated as the huge fires consumed all the oxygen.

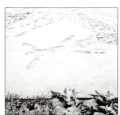

The RAF, under Air Chief Sir Charles Portal, were convinced that bombing alone would win the war. He argued for enough aircraft to make 25 million Germans homeless, kill 900,000 and seriously injure 1,000,000. As the historian Max Hastings has written, "If, as Portal's biographer argues, his purpose in mounting the bomber offensive was never to kill civilians as such, then he was now hoping to achieve the most dramatic by-product in the history of strategy." [4]

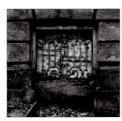

It took weeks to dig through the rubble and recover the bodies. Where the remains were only ash, they were taken to the mass graves in a newly created cemetery on the outskirts of the town. In places the heat had been so fierce that when some of the shelters were opened the only trace of the vaporised victims was a yellow-green slime that coated the walls and smelled terribly.

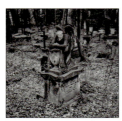

"In the centre there was no escape. The town was a mass of flames. People, burning like torches, jumped into the River Elbe on this cold February night. Screams and cries for help were heard everywhere. The embankment was covered in bodies or pieces of flesh. Many who had gone there after the first raid had not heard the second warnings and met their deaths in the open, as the bombs fell." [5]

For every ton of bombs dropped by the Luftwaffe, the British dropped 315 tons in return. In Oct 1943, Harris asked the Air Ministry to stop denying to the Press the real nature of his work. "The aim of the Combined Bomber Offensive… should be unambiguously stated [as] the destruction of German cities, the killing of German workers and the disruption of civilised life throughout Germany." [6]

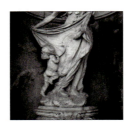

"Thousands of dead filled the streets. On the streets, no one could survive the firestorm. They had met a terrible death – some, having died through lack of oxygen, seemed to be sleeping; others had shrivelled in the intense heat, adult bodies shrunk to two or three feet, like tree trunks turned to charcoal." [7]

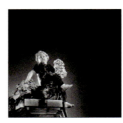

The survivors could not dig enough graves and in the early spring warmth, there was a real threat of disease. In the Old Market Square, steel girders were arranged to form a giant grate, and wagon loads of the dead arrived for cremation in the open. 6865 corpses were disposed of this way. The same technique had been used at Auschwitz when the crematoria had been unable to keep up with especially large numbers of killed Jews.

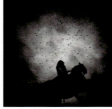

In the first four months of 1945 there were 36 major Bomber Command operations: 528 and 1,107 aircraft went on two nights to Dortmund, 717 and 720 to Chemnitz, 276 to Kassel, 805 to Dresden, 654 to Munich, 521 and 293 to Nürnberg, 500 to Potsdam, 597 to Wiesbaden, 349 to Worms, 458 to Mainz, 478 to Mannheim and 238 to Bonn. 181,000 tons of bombs were dropped in these last months, 20% of the tonnage dropped throughout the entire war.

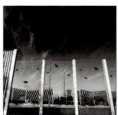

At 200 miles distant, the departing aircrews could still see the city burning, a faint orange glow on the horizon of the night sky, like a false dawn. The official history of the RAF discusses the carpet bombing of Dresden and calls it, "the crowning achievement in the long, arduous and relentless development of a principle of bombing." [8]

1 Stephen A Garrett, 'Ethics and Airpower in World War Two.' London 1993 p.45
2 Max Hastings, 'Bomber Command.' London 1993 p.342 Bomber Command briefing notes issued on the eve of the Dresden raid.
3 Hilary St. George Saunders, 'The Fight Is Won.' London 1954 p.271
4 Hastings, ibid. p.180
5 Survivor Erika Dienel writing in the Independent On Sunday Review, 'Half a Day In Hell.' 3rd May 1992
6 Garrett, ibid. p.193 and p.32. Horst Boog, introduction to Sir Arthur T. Harris, 'Despatch on War Operations.' London 1995 p.xli
7 Dienel, ibid. p.5
8 Garrett, ibid. p.20

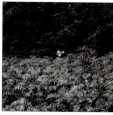

"The battlefield is desolate, as in any war and stretches wider... on the one side, millions of starving peasants, their bodies often swollen from lack of food; on the other, soldier members of the OGPU (Stalin's secret police). They had gone over the country like a swarm of locusts and taken away everything edible; they had shot or exiled thousands of peasants, sometimes whole villages; they had reduced some of the most fertile land in the world to a melancholy desert." [1]

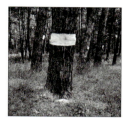

The forests at Bykivnya, near Kiev hide the mass graves of 200,000 victims, some from the Famine but mostly from the Purges at the end of the 1930's. Since Perestroika, families have been able to visit the area and mark the trees with home-made commemorative plaques or banners.

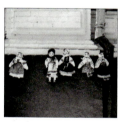

Stalin possessed in abundance "the superstitious and deep-seated fear of the peasantry as a whole, the feeling on the part of the Communists that a vast, inert, and yet somehow threatening mass of people barred Russia's path to industrialisation, modernity, and socialism; that a kingdom of darkness must be conquered before the Soviet Union could become the promised land." [2]

In one village, a woman was sentenced to 10 years for cutting 100 ears of corn from her own plot, a fortnight after her husband had died of starvation. A point of absurdity was reached when not showing signs of malnutrition was a cause for suspicion. "The alert eye of the OGPU," ran a typical press announcement, "has uncovered and sent for trial the fascist saboteur who hid a loaf of bread under a pile of clover."

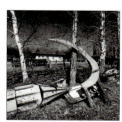

"A ruthless struggle is gong on between the peasantry and our regime. It is a struggle to the death. This year was a test of our strength and their endurance. It took a famine to show them who is master here. It has cost millions of lives, but the collective farm system is here to stay. We've won the war." Leading Party member M.M. Khateyevich. [3]

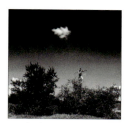

As the famine took hold, rather than alleviation, the Party piled on the pressure. From August 1932, the carrying of loaves was labelled 'speculation,' punishable by shooting. The Law On The Inviolability Of Socialist Property passed in the same month made it a capital offence to pick up spoiled and rotting heads of corn at the side of fields, and the court in Kharkov passed 1,500 death sentences in one month alone.

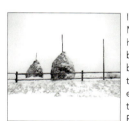

Platform for drying corn, Ukrainian Museum of Folk Architecture and Life, Pyrohiv, Kiev. By the winter of 1932 "People were eating straw and lime-tree leaves, making porridge from bark and nettles. I went to see my uncle, and they served a dinner. There was a stew – I saw something strange – tails sticking out of it! It was made from mice!" [4] The abundance of mice was perhaps explained by the fact that in places, cats were killed and eaten. By boiling the heads for hours, a kind of jelly could be made.

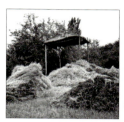

"In a little park by the station, dekulakised peasants from the Ukraine lay down and died. You got used to seeing corpses there in the morning; a wagon would pull up and the hospital stable-hand, Abram, would pile in the bodies. Not all died; many wandered through the dusty, mean, little streets, dragging bloodless blue legs swollen from dropsy, feeling out each passer-by with dog-like, begging eyes." [5]

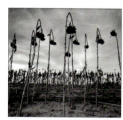

In the Carpathian Mountains near Mukacheve. In Mala Lepetykha, sick horses that had been killed and buried, were dug up two weeks later by starving peasants. For this crime, the villagers were shot. There were even arrests for cannibalism; the theft of a pig in Kalmazorka in Poltava province led to a house-to-house search that discovered a child's body in the process of being cooked. In Bilovusivka, 18 bodies were found in a well with all the flesh removed.

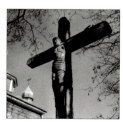

Village crucifix at the Folk Architecture Museum, Pereyaslav-Khmelnytsky. "I saw one such flat-top cart with children lying on it. They were just as I have described them, thin elongated faces, like those of dead birds, with sharp beaks... Some of them were still muttering, their heads still turning. I asked the driver about them, and he just waved his hands and said: "By the time they get to where they are being taken, they will be silent too." [6]

1 Malcolm Muggeridge, Manchester Guardian, 1932. Quoted in Robert Conquest, 'Harvest of Sorrow: Soviet Collectivisation and the Terror-Famine.' Oxford, 1986
2 Barbara B. Green, 'Stalinist Terror and the Question of the Genocide.' in Alan S. Rosenbaum (ed.) 'Is The Holocaust Unique?' Oxford 1996 p.142
3 Conquest, ibid.
4 Anna Reid, 'Borderland: A Journey Through The Ukraine.' London 1997 p.115
5 Reid, ibid. p.127
6 Reid, ibid. p.131

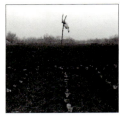

The lessons Hitler drew from the Armenian genocide are shown in a 1931 interview with the Leipziger Neueste Nachrichten. "Think of the biblical deportations and the massacres of the Middle Ages... and remember the extermination of the Armenians... One eventually reaches the conclusion that masses of men are mere biological plasticene." [1]

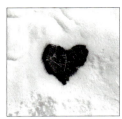

To the Prefect in Aleppo from Minister of the Interior, Talaat Pasha, 15/Sept/1915: "You have already been informed that the government... has decided to destroy completely all the indicated persons living in Turkey... Their existence must be terminated however tragic the measures taken may be, and no regard must be paid to either age or sex, or to any scruples of conscience."

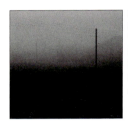

Djevdet Bey was commander of what became known as the Kesab Taburi, the Butcher Battalions. He acquired the name 'the Horseshoer,' due to his habit of nailing horseshoes to the feet of Armenian priests.

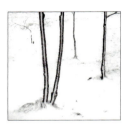

"When I scraped away the earth on the other side of the crevasse, an entire skeleton was revealed and then another and a third, so closely packed that the bones had become tangled among each other. Every few inches of mud would reveal a femur, a skull, a set of teeth, fibula and sockets, squeezed together, as tightly packed as they had been on the day they had died in terror in 1915, roped together to drown in their thousands." [3]

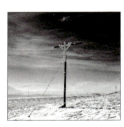

The newly invented telegraph was what made the genocide possible, allowing the authorities swift and co-ordinated action against the unsuspecting Armenians. Survivors tell stories of seeing priests crucified.

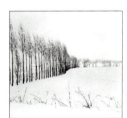

Sometimes convoys were murdered to save them having to walk further. Twenty thousand were thrown to their deaths in the Kemakh Gorge; at Erzincan, the number of corpses in the Euphrates was so large it caused the river to divert, and at Shaddadah, 3,000 were burned alive in the caves beneath the desert. Talaat later asked the ambassador to arrange for the Turkish state to cash the policies of those Armenians who had taken out life insurance with American companies.

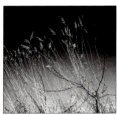

The Italian consul in Trebizond recalled; "The lamentations, the tears, the abandonments, the many suicides, the instantaneous deaths from sheer terror, the sudden unhinging of men's reason, the conflagrations, the shooting of victims in the city... the hundreds of corpses found every day on the exile road... [those] placed on board ships and capsized and drowned in the Black Sea... These are my last ineffaceable memories of Trebizond, memories which still, at a month's distance, torment my soul." [2]

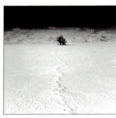

The evidence of an intention to commit genocide is incontrovertible. Talaat told the US ambassador, 'We have been reproached for making no distinction between the innocent Armenians and the guilty, but that was utterly impossible, in view of the fact that those who were innocent today might be guilty tomorrow.'

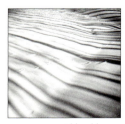

The convoys were subjected to rape, robbery and death by dehydration. One group of 18,000 that left Malatya was reduced to 150 by the time it reached Aleppo. On the banks of the River Kharbour, women were sold to Kurds and Arabs – 20 piastres was the price for a virgin, but only 5 piastres if the woman or girl had been raped. An American who toured the area wrote, "Mutilation, violation, torture and death have left their haunting memories in a hundred beautiful Armenian valleys."

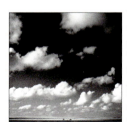

The Turkish Government denies that their predecessors committed genocide. They have intimidated writers, blackmailed businesses and governments, bankrolled historians,[4] jailed archaeologists [5] and rented heavyweight PR firms. The list of excuses for the massive number of Armenian deaths usually includes poor planning, corrupt officials and the actions of common criminals. None of this, however, can hide that the killing was systematic, premeditated, centrally planned and utterly genocidal.

1 Kevork B. Bardakjian, 'Hitler and the Armenians,' Cambridge MA, Zoryan Institute 1985 p.28
2 Richard G. Hovannisian, 'Etiology and Sequilae of the Armenian Genocide,' in 'Genocide; Conceptual and Historical Dimensions,' edited by G.J. Andreopoulos,

Pennsylvania 1997 p.125
3 Journalists Robert Fisk writing about the site of the concentration camp at Margada, eastern Syria, in the Independent magazine, London 5th April 1992 p.23
4 Roger W. Smith, Eric Markusen and Robert Jay Lifton,

'Professional Ethics and the Denial of the Armenian Genocide.' Holocaust and Genocide Studies, vol.9, No.1, Spring 1995
5 William Dalrymple, 'Armenia's Other Tragedy,' The Independent magazine, London 18th March 1989 p.30

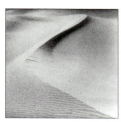

"The reports about the second Negro rebellion in South West Africa have filled all Germans with dismay. In order to give that race an idea of the power we wield over them it is necessary that our soldiers, whenever they withdraw, thoroughly poison their water supplies. After all, we are not fighting against an enemy respecting the rules of fairness, but against savages. Never must we allow the Negro to prevail." – letter from an ordinary citizen to the Kaiser, 1904.

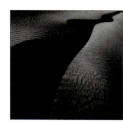

A native soldier fighting with the Germans swore under oath: "When the engagement was over, we discovered eight or nine sick Herero women who had been left behind. Some of them were blind. They had a supply of water and food. But the German soldiers burned them alive by setting fire to the hut." When questioned, a German officer replied "So what? They might have infected us with some disease."

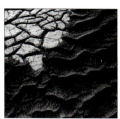

"Anyone familiar with the life of African and other less civilized non-white peoples knows that Europeans can assert themselves only by maintaining the supremacy of their race at all costs. Moreover, anyone familiar with the situation knows that the swifter and harsher the reprisals taken against rebels, the better the chances of restoring authority"– German Colonial League pamphlet.

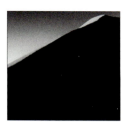

"I was present when the Herero were defeated [at the Waterburg.] After the battle, all men, women and children who fell into German hands, wounded or otherwise, were mercilessly put to death. Then the Germans set off in pursuit of the rest, and all those found by the wayside and in the sandveld were shot down or bayoneted to death. The mass of the Herero men were unarmed." – sworn deposition of white farmer, Jan Cloete. [4]

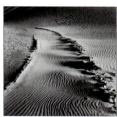

Von Trotha's extermination order was: "All Herero must leave the country. If they do not do so, I will force them with cannons to do so. Within the German borders, every Herero, with or without weapons, with or without cattle, will be shot. I no longer shelter women and children. They must either return to their people or they will be shot at. This is my message to the Herero nation."

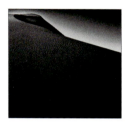

An elderly survivor talked of the struggle with thirst in the Omaheke, of women killing their babies to let the men have their breast milk, of men drinking the blood of dead cattle, of people even drinking the blood of others who had died of dehydration.

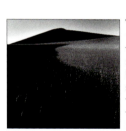

Von Trotha wrote to the Governor, "Throughout my period of duty here the eastern border of the colony will remain sealed off and terrorism will be employed against any Herero showing up. That nation must vanish from the face of the earth. Having failed to destroy them with guns, I will achieve my end in that way." [2]

"Mothers carried their dying infants on their backs and sometimes did not even realise when the children had died. Wild animals followed this trail of suffering and preyed upon the dead and those too weak to defend themselves…

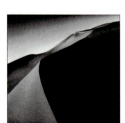

The study of the German General staff noted, "The arid Omaheke was to complete what the German Army had begun: the extermination of the Herero nation." [3]

"…At first the dead were still buried, but soon they were simply abandoned. Each person who could remain on his feet kept himself going as long as possible. Here and there two friends helped and encouraged one another but ultimately one of them would collapse. The other wanted to help, but did not have the strength. A sad glance of farewell had to suffice and then it was struggling forward again, until the survivor also fell to the sand." [5]

1 Gerhard Pool, 'Samuel Maherero.' Windhoek 1991 p.276
2 Horst Dreschler, 'Let Us Die Fighting; The struggle of the Herero and Nama abainst German Imperialism.' London 1980 p 161
3 Dreschler, ibid. p.156
4 Dreschler, ibid. p.157
5 Pool, ibid. p.276

In memoriam, Nyarubuye and Ntarama, 1994

I would like to extend my heartfelt thanks to:
Leon Greenman
Paddy Donnelly at Cafod in London
Geoff Sayers at Oxfam in Oxford and Oxfam's staff in Kigali
Teresa Swiebocka at the Auschwitz-Birkenau Museum
Professor James Mace in Kiev and Svetlana Lozorska in Poltava
Anush Hovannisian in Yerevan
Dr. Robert Jebejian in Aleppo
Alessandro Caldarone in Arusha and Ewald Behrschmidt in Nürnberg
John Herlinger at Fotospeed/Sterling
Dr. Gordon Turnbull
Nancy Leigh Brennan of Winnipeg
Dewi Lewis
Martin Colyer
Michael Ignatieff
Brigitte Lardinois
Shirley Read
Jenny Matthews
Paul Lowe
Simon James
David Brownridge
Stella Halkyard of the John Rylands Library in Manchester
Monica Otten
Richard Maude and Nina Hall

online resources:
www.formost.force9.net

Original Prints made using Fotospeed chemistry and Sterling Paper

Fotospeed

STERLING